# THE LOWRY LEXICON

## An A-Z of L.S. Lowry

*Shelley Rohde*

In gratitude and love.

To Michele,
*for faith*

To Rowan,
*for the insight of a child*

And to Billy,
*in the hope that he might grow up to see
the beauty Lowry saw*

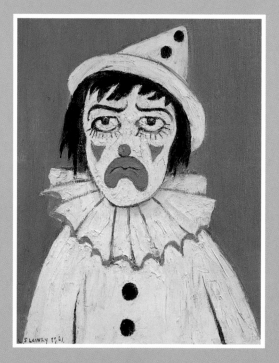

*The Clown (1961)*

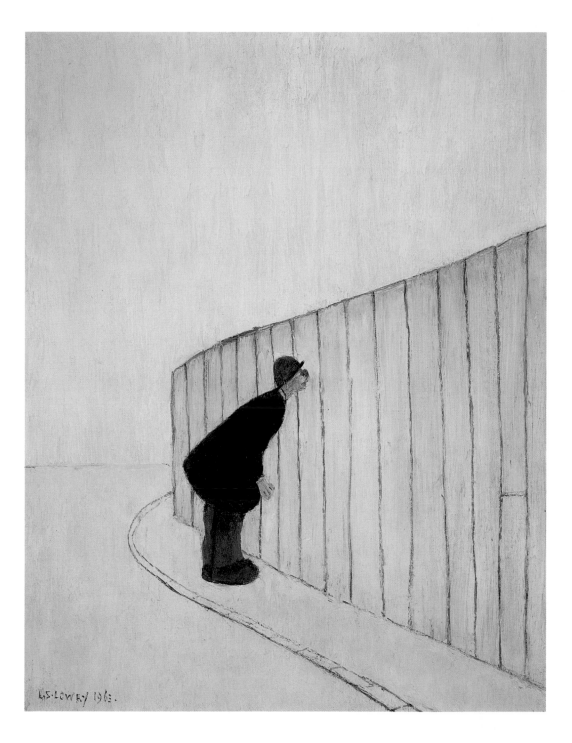

*Man Looking Through a Hole in The Fence (1963)*

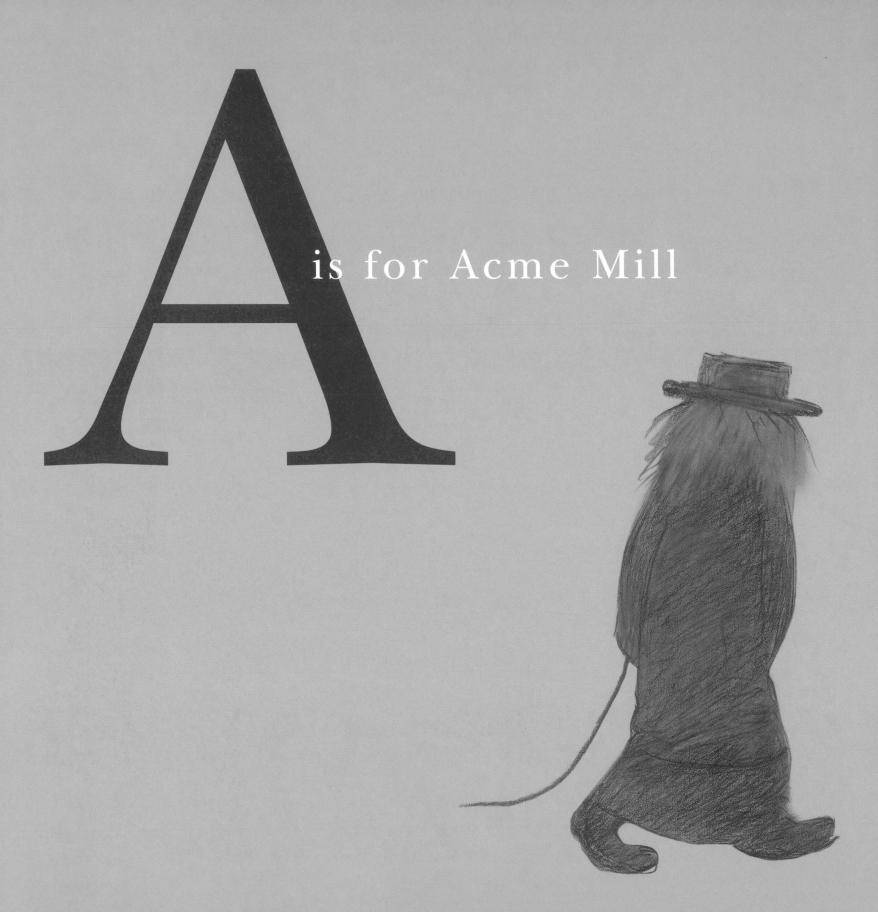

A is for Acme Mill

# A is for Acme Mill

Laurence Stephen Lowry was a chronicler of industrial England. He painted stark mills and black chimneys, and scurrying homunculi cowed by life.

*The Lake (1937)*

But he painted much else besides, such as formal portraits
and pastel yachts on pastel seas... and strange-looking people
with B I G   F E E T !

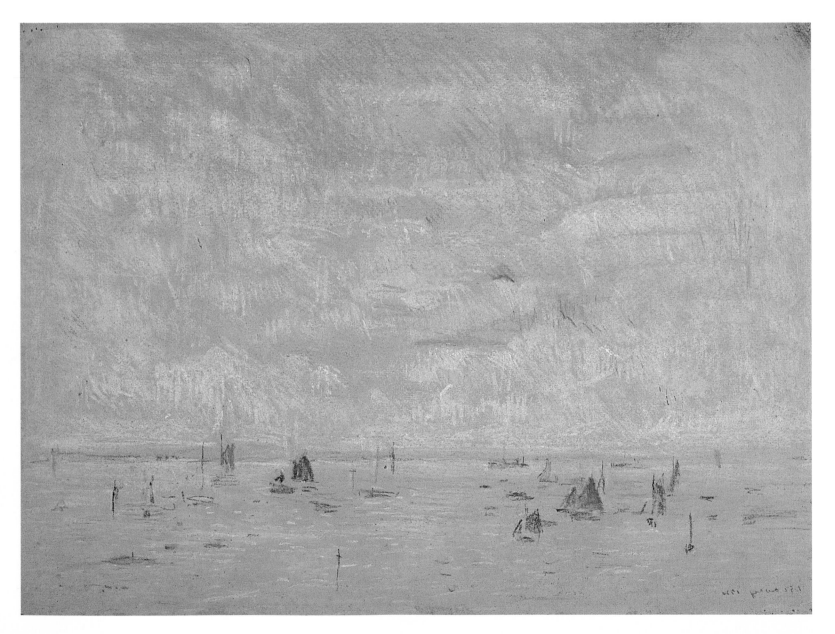

*Yachts (1920)*

But it was for painting the 'poetry of the English industrial landscape' that he became famous.

Lowry was a compulsive storyteller. He delighted in talking about things that happened to him in what he called 'The Battle of Life', although, if the truth were told, nothing of particular interest happened to him at all.

He never went abroad, never flew in an aeroplane, never owned a car nor learned to drive; he didn't smoke or drink and he never married. None of which, curiously, made him boring company; it just meant that he became adept at turning the most ordinary event into an extraordinary tale, a tale to be told and told and told again, refined and embellished and delivered with the immaculate timing of one of the pier-end comics he so enjoyed as a child.

He was, as a critic once remarked, God's gift to journalists. A born raconteur.

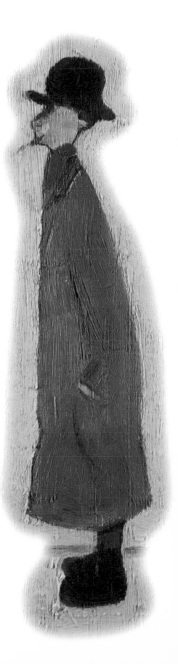

*Gentleman Looking at Something (1960)*

One of his favourite anecdotes was his story of how he came to paint the industrial scene. One day he was on his way to Manchester and he missed his train.

*"I remember that the guard leaned out of the window and winked at me as the last coach disappeared from the platform. I was very cross about that. I went back up the steps. It would be about four o'clock in the afternoon and perhaps there was some peculiar condition of the light or something... but as I got to the top of the steps I saw the Acme Mill, a great square red block with the little cottages running in rows right up to it. And suddenly, I knew what I had to paint."*

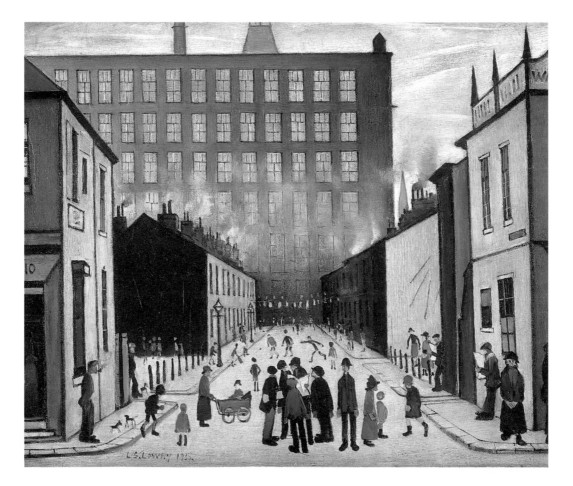

*Street Scene (1935)*

The way he told it made it sound a bit like Saint Paul on the road to Damascus. As if he had had a vision. Which, in a kind of way, he had.

Whether it all actually happened like that, doesn't really matter. Because that's the way it happened in his head.

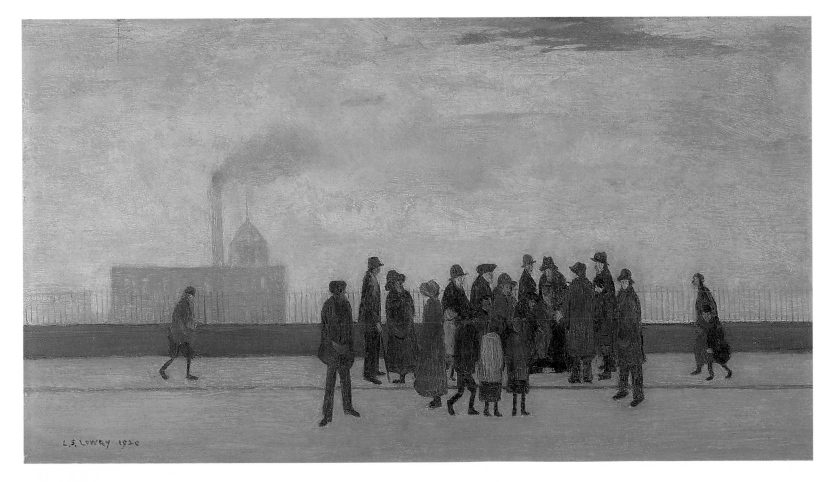

*Sudden Illness (1920)*

# B is for Beard

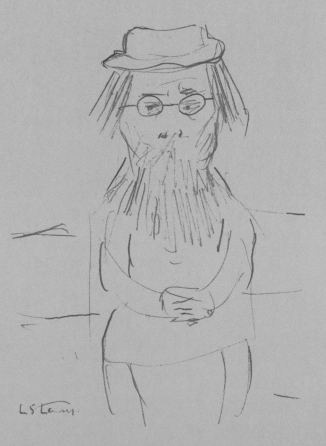

# B is for Beard

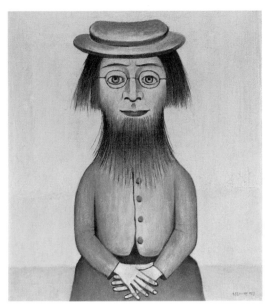

Lowry had the knack of spotting unusual looking people; or, maybe, it was simply the way he saw them. Someone once described him an entomologist stalking human insects with his butterfly net. He studied people. He collected them. The stranger they were, the better he liked them. And the more he wanted to paint them.

One of his strangest paintings is THE WOMAN WITH A BEARD. Lowry told his friend Monty Bloom, a man who collected Lowry paintings to the point of addiction, that he really did see a woman with a beard. She was, he said, travelling in the same carriage with him on a train going from Cardiff to Paddington in London.

*"She had a very nice face and quite a big beard. Well, sir, I couldn't let such an opportunity pass, so I began almost at once to make a little drawing of her on a piece of paper. She was sitting right opposite me. After a while she asked, rather nervously, what I was doing.*

*I blushed like a Dublin Bay prawn and showed her my sketch... the one from which I later made my painting of her. At first, she was greatly troubled, but we talked, and by the time the train reached Paddington we were the best of friends. We even shook hands on the platform."*

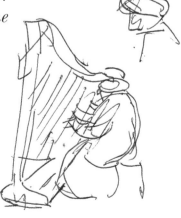

(top) Woman With a Beard (1957)
(bottom right) Sketch for Man Playing Harp, Brighton (1963)

But she was not the only one. Or so Lowry said.

He saw another bearded woman pushing a pram through the streets of Winchester.

*"I'm afraid she wasn't quite so nice. The moment I saw the good lady, I pulled a scrap of paper from my pocket and hurried alongside her scribbling away. Well, my dear sir, her language… oh! It was quite appaling. Oh, terrible! I wouldn't dare repeat what she called me."*

As soon as Monty Bloom saw THE WOMAN WITH A BEARD, he wanted it. He bought it, even though he could barely afford it, and hid it in his office rather than confess to his family that he had acquired yet another strange Lowry. He called it *"The Working Man's Mona Lisa"*.

*Sketch for Woman with a Pram, Winchester (1959)*

*Girl in a Red Hat on a Promenade (1966)*

# C

is for Cripples

LS Lowry

# C is for Cripples

Lowry and his good friend David Carr, two artists well matched in their fascination with all things quirky, delighted in showing each other their work. The more curious the picture, the better it was received, the greater the interest. But when Lowry showed David the half-finished canvas of THE CRIPPLES, David began teasing his friend:

*"You couldn't have seen all those at one time,"* he insisted, knowing full well that Lowry would be unable to resist the challenge. *"Right,"* said Lowry, plonking his old hat hard on his head and grabbing his walking stick. *"Come with me. I'll show you."*

He took his friend to Piccadilly Gardens in Manchester, where they caught a bus to Rochdale. It was, he said, about three in the afternoon when the odyssey began:

*"Up Oldham Street we saw a man on a trestle… then a while on we saw an old gentleman being helped on to a bus, then a man with one leg, then a man with one arm and, I'm ashamed to say, I was quite pleased."*

Between Manchester and Rochdale that day they counted 101 memorable figures.

*(top) Detail from In A Park (1963)*
*(bottom right) Detail from The Cripples (1949)*

When Lowry had finished the painting, he wrote to report progress to David, the only man he trusted to understand what he was trying to do.

*"I have operated on the man in the far distance and given him a wooden leg… I think you would approve. I still laugh heartily at the hook on the arm of the gentleman… that suggestion of yours was a master stroke."*

Lowry often said that he felt a great affinity with the people who inhabited his pictures. He identified with them.

*" There, but for the Grace of God, go I, "* he would say time and again.

And to the dealer who sold the picture he said:

*" There's a grotesque streak in me and I can't help it. I can't say why I'm fascinated by the odd, but I know I am. I'm attracted to sadness and there are some very sad things. I feel like them."*

Whether it was because he had failed to gain his mother's approval, or to fulfil her expectations of him, or because at art school he was a misfit, whatever the reason, this was a remark he was to repeat in countless interviews:

*" I feel like them. "*

And when, many years later, a young artist questioned him about THE CRIPPLES, and another, similar painting called IN A PARK, he said:

*"The thing about painting is that there should be no sentiment. No sentiment."*

The student believed what Lowry meant was that, in painting what he called the 'grotesques', the artist should never feel sorry for his subjects. He should simply paint them as he saw them, in a way that allowed observers to feel their own emotions rather than those imposed upon them by sentimentality.

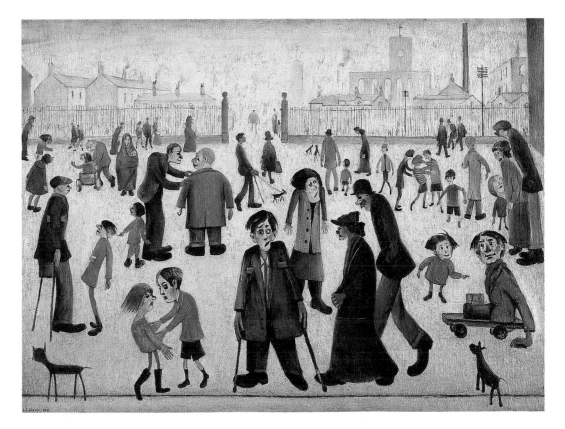

*The Cripples (1949)*

**is for The Dog With Five Legs**

# D is for The Dog With Five Legs

One day when Lowry was working at the Pall Mall Property Company, a tailor called Albert Dennis was looking at a print of one of Lowry's paintings in a shop window in St Anne's Square, Manchester. There was a church and a lot of steps and some people and a dog or two. Suddenly, Mr Dennis noticed that one of the dogs had five legs.

As he was a friend of Mr Lowry, it is not surprising that they found the same sorts of things comical. Mr Dennis thought a dog with five legs was comical. And he knew that Mr Lowry would find it comical too.

So he rushed off to find his friend to tell him what he had discovered. He found Lowry just coming out of his office for lunch and dragged him back to the shop window to look at the painting. Lowry stared at it for a long time.

*Detail from Two Dogs (1960)*

*"Well, I never,"* he said, with a straight face. *"And to think I checked it most carefully before I let it go. All I can say is that it must have had five legs. I only paint what I see, you know."*

And the friends laughed a lot, and Lowry told that story often to anyone who would listen. *"And do you know,"* he would say, *"you couldn't have taken one away."*

In Newcastle-upon-Tyne one evening, he related the tale to a young dealer called Simon Marshall, who had sold many a print of that picture. *"How could I never have noticed?"* asked Simon.

*"Ah, you didn't notice,"* Lowry replied, *"because I got the balance right. Four legs would have unbalanced the whole painting. Anyway, why shouldn't a dog have five legs?"*

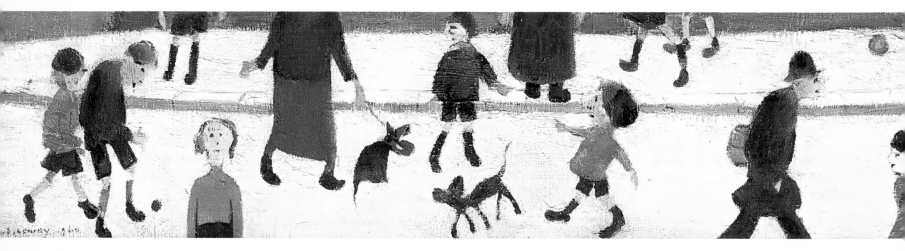

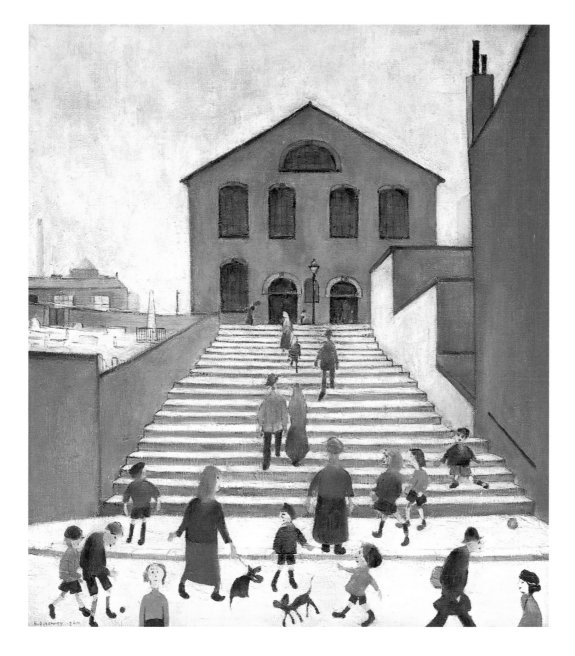

*Old Church and Steps (1960)*

# E is for Empty Seascape

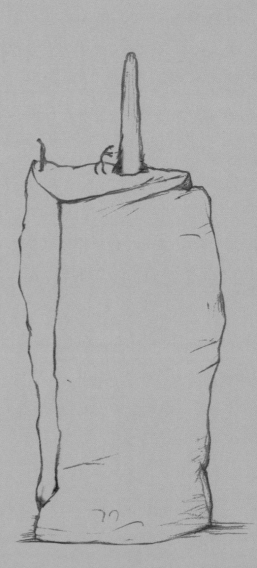

# E is for Empty Seascape

Throughout the 20th century, successive Directors at Salford Art Gallery, almost without exception, were keen admirers of Lowry's paintings. Which is why the City of Salford acquired so many of his works over the years.

But championing Lowry wasn't always easy. In 1954, the then Director of the Gallery, whose name was Ted Frape, proudly announced to the members of the Art Galleries Committee that he had just bought a Lowry seascape. The price was 54 guineas.

In those days, 54 guineas was a lot more than it is today. It was a great deal of money. The Councillors were horrified – and furious with Mr Frape. It was, they said, a ridiculous amount of money to pay for *"… three straight lines of colour, yellow or beige for the beach, blue for the sea and grey for the sky, with not a pebble on the beach, not a wave on the ocean, and not a cloud in the sky"*.

If there had been a mill, or a few people in clogs, or a chimney or two, they might have thought they were getting value for money. But this seascape was totally empty. There was nothing there but sea.

*Five Pillars in the Sea*
*(undated)*

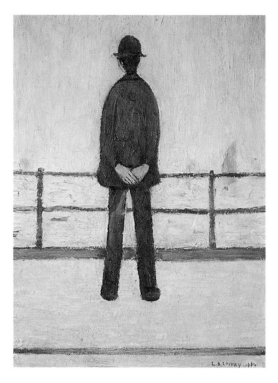

*"We've bought a pig in a poke,"* shouted one Councillor, very cross. *"It's a seascape, not a pig,"* snapped another.

It was not until a certain Alderman, who knew his colleagues well, pointed out that Salford's collection was actually going up in value that the objectors were out-voted and the purchase approved.

After the meeting, a newspaper reporter went away and wrote about it all in the *Manchester Guardian*, which, of course, amused Lowry enormously.

*"I've often been tempted to put a mill chimney in the middle of an empty seascape,"* he told Monty Bloom. *"But then, they'd only call me Salvador Lowry."*

*Man Looking Out To Sea (1964)*

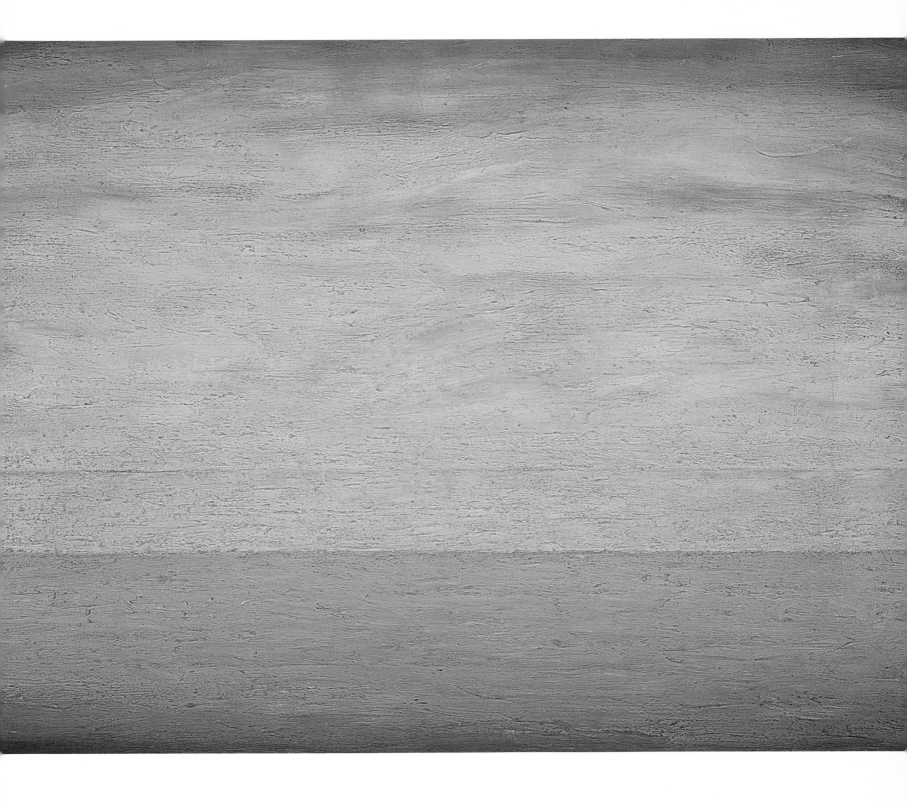

*Seascape (1952)*

All his life Lowry had been drawn to the sea. He would walk beside it for hours or stand watching the inexorable ebb and flow of the tide along the shore. He went out on it, in rough weather and in calm, riding in sturdy fishing boats from the North Sea fleet. He painted it… vast empty tracts of creamy waves, or bulky black tankers steaming into dock, or strange obelisks rising from the depths.

Most of all, he talked about it.

*"It's the Battle of Life… the turbulence of the sea… and life's pretty turbulent, isn't it?"* he would say.

*"I am very fond of the sea, of course, I have been fond of the sea all my life: how wonderful it is, yet how terrible it is. But I often think… what if it suddenly changed its mind and didn't turn the tide? And came straight on? If it didn't stop and came on and on and on and on and on…"*

And then he would stop and stare hard at whoever he was with and say in doom-laden tones:

*"… and that would be the end of it all."*

Then, more often than not, he would laugh… a huge guffaw, a great explosion of noise that echoed across the deserted shore, just in case anyone thought he was beginning to take life too seriously. Which, of course, would never do.

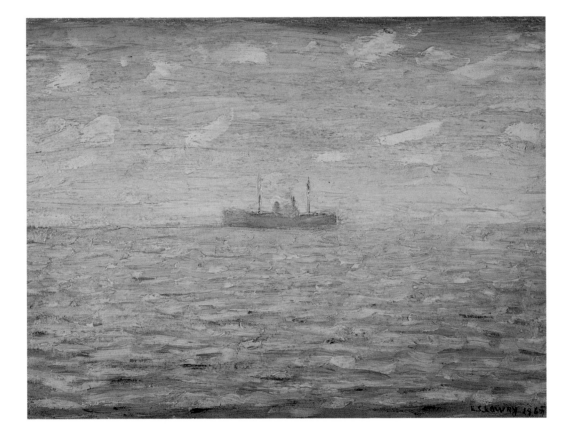

*Waiting for the Tide (1965)*

 is for Fame

# F is for Fame

Fame came to Lowry late in life, at an age when most men have abandoned their youthful dreams. He was 52 years old when he was given his first London show, over 60 when he began to receive critical acclaim, and in his 70s before his pictures achieved high prices.

When fame did come, slowly, painfully, almost grudgingly, it was all 'too late'. He reacted to the advent of this unfamiliar thing called recognition with a typical bit of Lowry role-playing: the insouciant, the dispassionate, a stranger to dedication, a man who painted 'to pass the time', the artist *malgré lui.*

He knew what his mother had thought of his paintings. She hated them and had made no secret of the fact. In life she had denied him her approval and, now that she was dead, praise and honours meant nothing to him. *"It has all come too late,"* he said.

His mother had been the family arbiter of taste, a fine pianist and a lover of literature. After her death it was as if, in his heart, her son feared that Elizabeth Lowry's estimate of his art might indeed be right and true.

Without her esteem, how could he be sure that the latter-day flatterers were not laughing at him behind his back? Just as they had to his face in the early days.

*An Artist (1955)*

And so, when people began calling him Lowry the Artist, with a capital 'A', as if he were someone special, he just laughed. *"I'm not an artist,"* he would say. *"I'm a man who paints pictures."*

He worked in a tall, dark, cluttered room at the back of his house. He called it his workroom. He would get quite cross if others called it a studio. He thought that was pretentious.

*"The longer the beard, the shorter the art,"* he would announce in the face of artistic arrogance. There was nothing he liked better than deflating pomposity. Both in life and in his pictures.

In fact, he loved to tease. And to play roles. If a visitor arrived expecting the cloth-capped yokel that many establishment critics assumed him to be, that is the part he would play. Instead of a man who went to the theatre and to concerts, who painted to the sound of grand opera, read poetry and French philosophy, and took the *Financial Times* each morning, they found exactly what their pre-conceptions had led them to expect.

One journalist, who had glimpsed beneath the façade, went away and wrote:

*"If he thinks he is being cast in that role, his inner demon of perversity will make him act the part. The Lancashire accent broadens, the blue eyes glint, and one is in for some merciless poker-faced mickey-taking."*

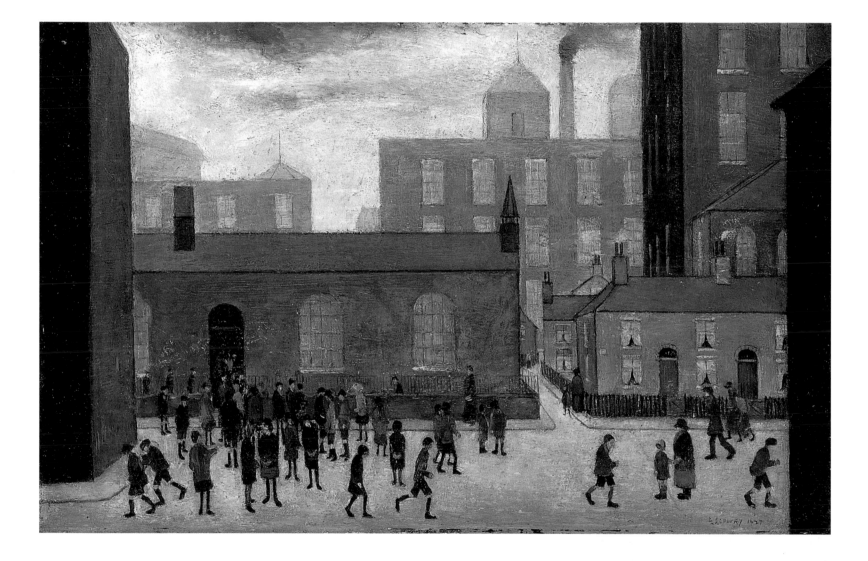

*Coming Out of School (1927)*

# G

is for God Daughter

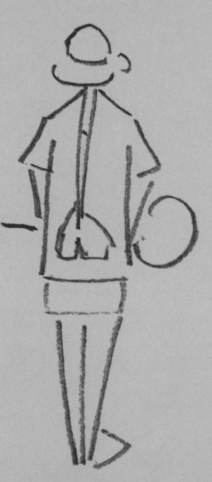

# G is for God Daughter

Every year, the Royal Academy of Arts expects its members to submit a painting. Lowry was elected an Associate in 1955, at the age of 67, and, soon after he was elected, he surprised them all.

He did a portrait. Of a young woman. This came as quite a shock. People were used to Lowry making pictures of tall chimneys and terraced houses and fetid, stagnant ponds. Most of them, including his fellow Academicians, were unaware that there was much, much more to L S Lowry than the black landscapes of the industrial North.

When people came to ask about the portrait, he grinned hugely. He relished their surprise. The girl, he told them, was his god-daughter. Her name was Ann. She was, he said, the "*only person who can tell me what to do*".

He would tell of the holidays they took together… touring the narrow lanes of Devon and Cornwall in the two-seater Rolls Royce she had been given for her 21st birthday, or to Scotland to spend the week with her three maiden aunts for the Edinburgh Festival.

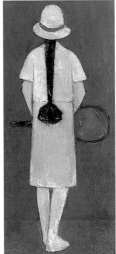

*The Tennis Player (1927)*

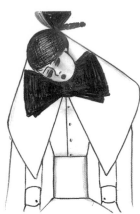

After that, people started taking a closer look at Lowry's paintings and realised that, for years, he had been putting a young woman in many of his pictures. Sometimes she had her hair in a plait, sometimes she carried a tennis racquet, and sometimes she was standing on top of a sandcastle as if she ruled the world.

There is an early Lowry drawing called ON THE SANDS which shows a couple of people, at various ages in life, repeated time and time again, sometimes young, sometimes old, walking, sitting, standing, but always together. And the curious thing is that every girl in the picture looks like Ann and every boy looks like a young Laurence Stephen Lowry. Every woman has her features, every man his stance. And yet this drawing was done in 1921, forty years before the god-daughter came on the scene.

People were always wanting to know who these girls Lowry painted were in real life, and he would tell a different story each time. Sometimes she was a farmer's daughter from Swinton Moss, near Manchester. Sometimes she was a ballet dancer called Maud who lived at Lytham St Anne's. Sometimes she was the schoolgirl daughter of a friend, who came to visit on her roller skates. Curiously, he would always make it sound as if the one he was talking about at that moment was the important one.

But, even now, a quarter of a century after his death, no-one really knows who Lowry's Dark Lady was. It was still his secret when he died.

*Girl with Bow (c 1973)*
*Girl on the Sands (c 1921)*

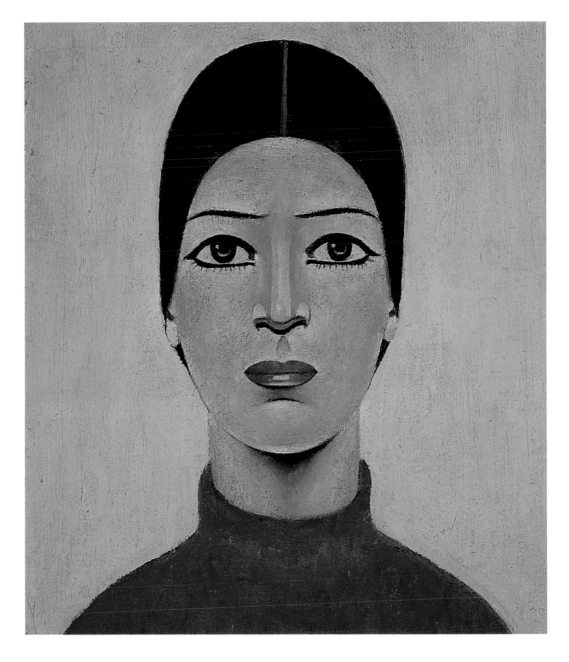

*Portrait of Ann (1957)*

# is for Horse

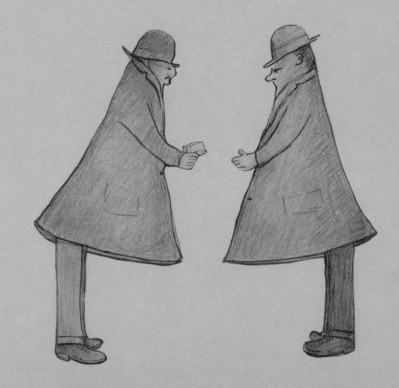

# H is for Horse

Lowry couldn't draw horses. At least not very well. Which was quite a problem for him, because when he began painting there were no such things as motor cars. Everyone went about in carriages or in horse-drawn trams and goods were delivered by horse and cart.

He once really surprised his friend Monty Bloom when they were out walking in a busy street in Huddersfield. *"Don't those cars over there look funny,"* said Lowry, *"all going along without horses."*

Over the years he became very clever at avoiding the problem. In COMING FROM THE MILL, there is a man driving a horse and cart, but the horse is behind a wall so that you can't see its legs. It was the legs that Lowry couldn't do.

*Detail from Coming from the Mill (1930)*
*Detail from Northern Hospital (1926)*

He used the same ruse in NORTHERN HOSPITAL. In another picture, two people are positioned strategically in front of a horse, exactly where the back and front legs should be. In yet another, the horse is just disappearing over the brow of a hill, so that only its ears can be seen.

Sometimes (or so he used to say) he would ask a child to draw a horse for him. But we don't know which pictures have horses in them that have been drawn by someone else. There may be none at all. And, then again, there may be lots.

Only Lowry knew. And he, of course, wasn't telling.

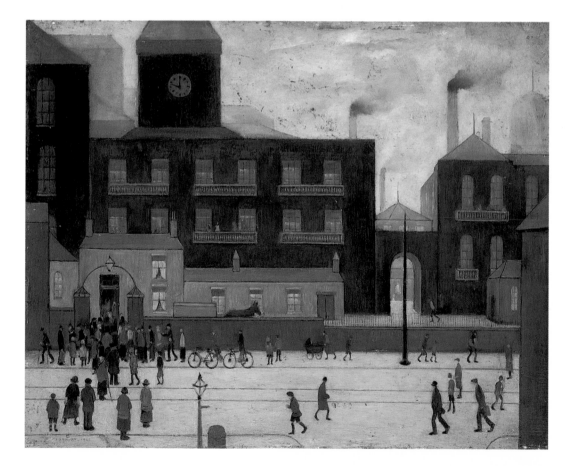

*Northern Hospital (1926)*

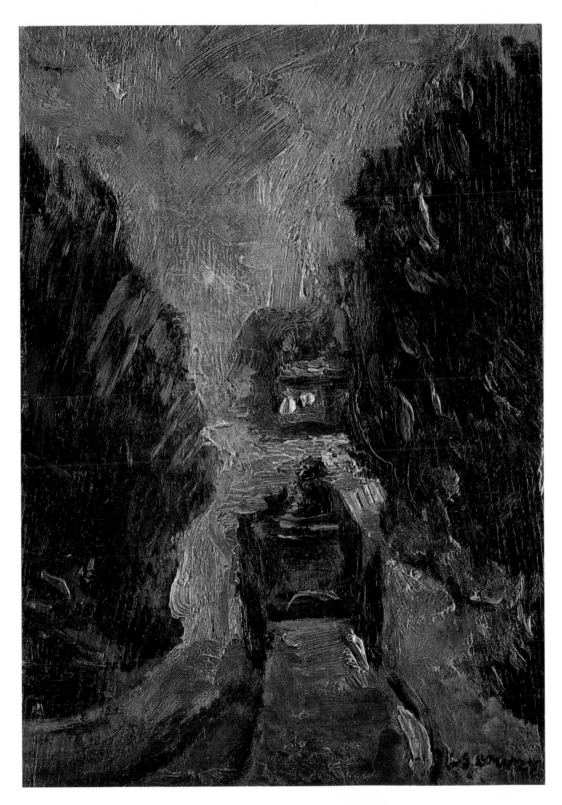

*Country Lane (1914)*

 **I** is for Island

# I is for Island

Lowry was attracted to desolation. It was as if he only really felt comfortable with things that were derelict or grim. He never seemed to get excited about conventional beauty in the way that he got excited about a stark old mill, or a black chimney, or a tumble of terraced houses.

He painted a great many bleak pictures, but one of the bleakest of them all was called AN ISLAND. He said of this picture:

*"AN ISLAND is an old house, long since unoccupied, falling further and further into decay. I seem to have a strong leaning towards decaying houses in deteriorated areas…"*

And again:

*"They are symbols of my mood. They are myself."*

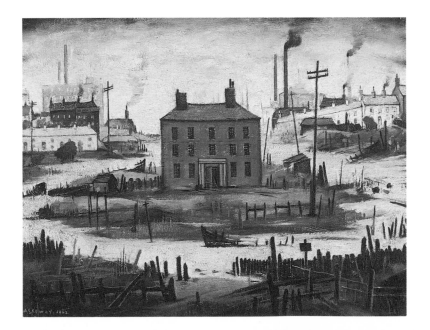

*An Island (1942)*

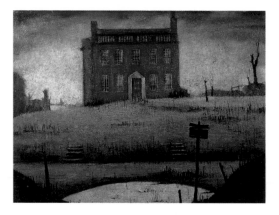

All his life Lowry had been a loner. An only child, he was much protected from the outside world by his mother. When he was little, he didn't have any friends to play with, and when he was taken to visit his cousins he would hide behind his mother's long skirts.

He lived with his parents in their big, dark house in Pendlebury, Lancashire, within sight and sound of the mills that so obsessed his early work. After his father died, he was left to look after his ailing mother alone. She took to her bed and stayed there for seven years, until she died.

In the evenings, when he got home from work, he would read to her until she fell asleep. Only then would he go up to the attic and paint until he could no longer keep his eyes open.

*"It was alright when he was alive, but after that it was very difficult because she was very demanding. I was tied to my mother."*

*The Empty House (1934)*

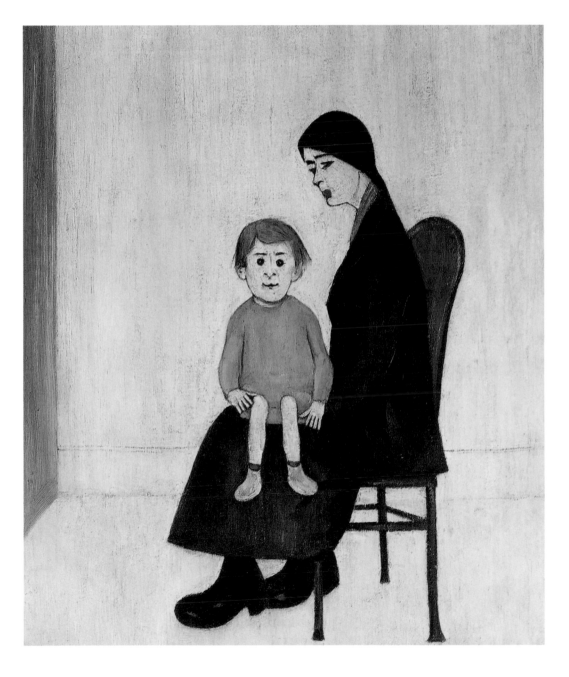

*Mother and Child (1956-7)*

# J

is for Judy (and Punch)

# J is for Judy (and Punch)

When Lowry was a boy, he would go on holiday to the seaside with his parents and his cousins, Billie and Bertie. They were all about the same age and enjoyed the same things. (Many years later he made a picture of Billie and Bertie with their father and called it FATHER AND TWO SONS. It was a dark, disturbing painting so, of course, Monty Bloom bought it.)

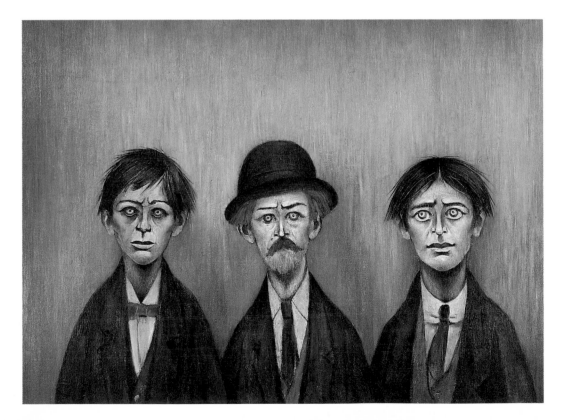

*Father and Two Sons (1950)*

The boys didn't always have enough money to get onto the pier, to see the Punch and Judy and the music-hall shows, so either Billie or Bertie would go first through the turnstiles and drop his ticket over the side for the others.

Often the ticket would blow away across the sands, and it always seemed to be Laurie who would have to run like mad to catch it. The others thought this was highly amusing but not as amusing as the jokes the pier-end comics told.

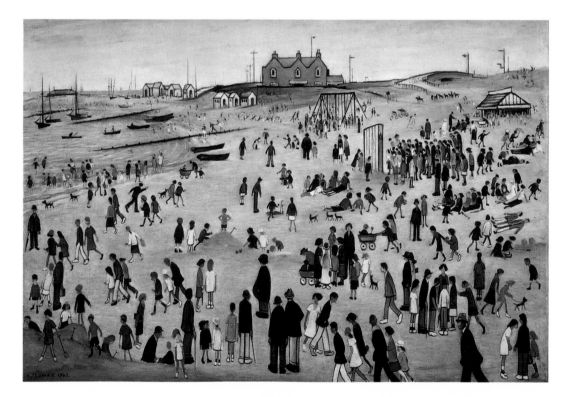

*July The Seaside (1943)*

*" My wife's gone to the West Indies. "*

*" Jamaica? "*

*" No, she went of her own accord. "*

Even when he was quite old, Lowry would laugh until the
tears ran down his face at the memory of these old jokes.
It was his sort of humour.

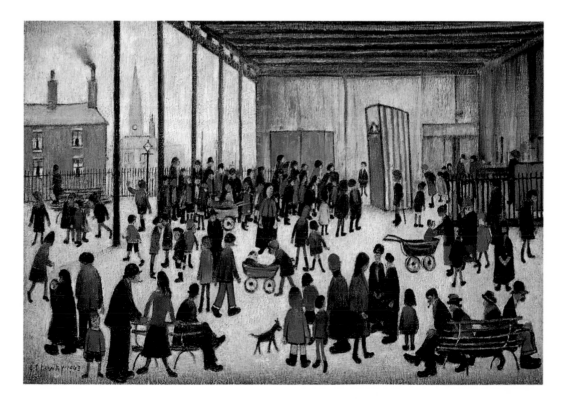

*Punch and Judy (1943)*

 **is for Kids**

# K is for Kids

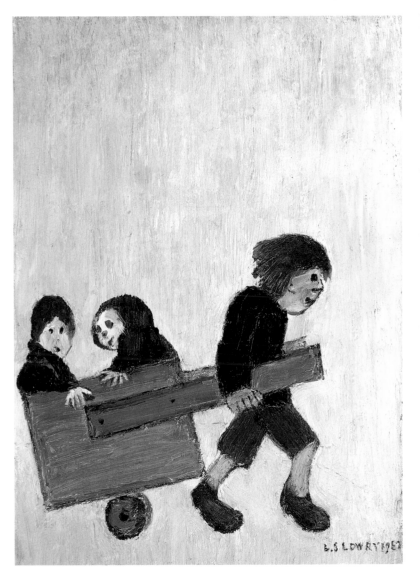

For an addicted observer of human nature, fate could hardly have allotted Lowry a more apposite job. For more than forty years he was a rent-collector, which meant that he spent most of each day walking round the narrow cobbled streets to collect money due from the people who lived in the terraced cottages that huddled round the mills of Salford.

And all the time he would be observing the antics of the people he met on his way. He watched the men weaving home from the pub or risking an illegal bet on a street corner. He watched the women in their shawls gossiping in doorways. But most of all he watched the children manipulating their parents and each other.

*Boy Pulling Cart With Two Children (1967)*

Sometimes, if he was in an especially good
mood, having seen something that really
appealed to him (like one boy kicking another
or a mother telling off her child), he would
drop a penny or two as he passed and pretend
he didn't notice the kids rushing to pick
them up.

After a while the local children got to know his
ways. They would follow him on his rounds,
almost as if he were the Pied Piper of Hamelin,
in the hope that he might drop the occasional
copper. And, of course,
he usually did.

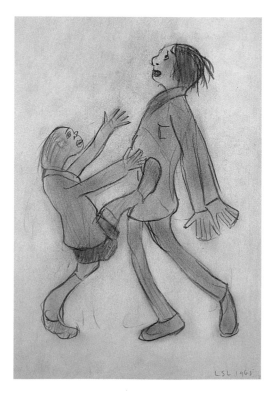

*(top) From the artist's sketchbook*
*Little Brother Kicking Big Brother (1965)*

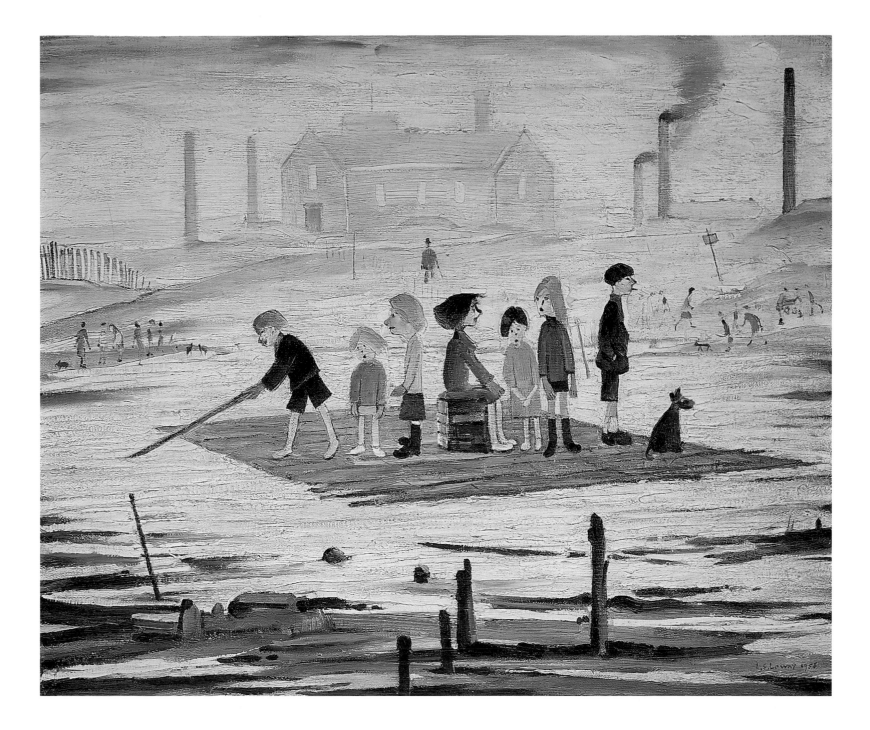

*The Raft (1956)*

is for Laying the
Foundation Stone

117, STATION ROAD,
PENDLEBURY,
NR. MANCHESTER.

# L is for Laying the Foundation Stone

A rather pompous man in Salford once declared that Lowry's pictures were *"An Insult To Lancashire"*.

The picture that caused all the trouble was called LAYING THE FOUNDATION STONE.

Most of Lowry's friends knew of his eccentric sense of humour. That's why they often told him about things they thought might appeal to his quirky view of the world. One day, one of his friends, a pottery artist called Edward Kent, persuaded him to go to a ceremony to celebrate the building of a new school.

*"It's right up your street,"* said Mr Kent, because he knew that Lowry enjoyed showing the ridiculous side of people who got puffed up with their own importance.

When Lowry arrived at the opening, he saw *"four rows of kids looking a picture of misery, singing oh so piteously… and the clergymen looking at the sky as if they wished themselves elsewhere, and the Mayor weighed down by his chain of office looking as if he wanted to get it over with and get to the match."*

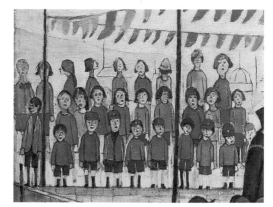
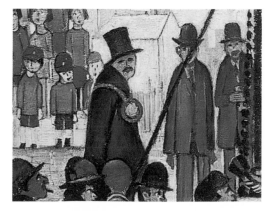

*Details from Laying The Foundation Stone (1936)*

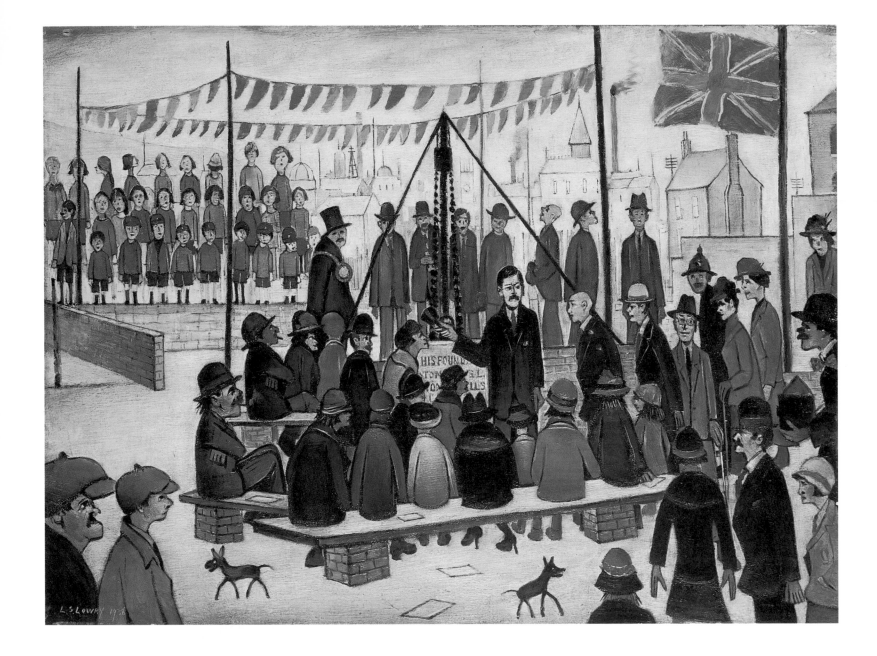

*Laying The Foundation Stone (1936)*

*"Well, I had to leave,"* Lowry said later with a grin.
*"I couldn't stand it. I couldn't help myself laughing."*

When Lowry had painted his picture, he showed it to the Mayor who, not being a pompous man, liked it very much. The Mayor took it to show to the City Fathers, but *"they were very, very angry"*. They thought the painting made them look ridiculous. The Vicar was particularly irate.

*"You are no gentleman, sir,"* he said to Lowry,
*"you are no gentleman to make fun of us like that."*

Lowry replied:

*"I don't pretend to be a gentleman, but I am entitled to paint what I see."*

And he put himself and his friend, both wearing cloth caps and not looking the least bit important, in the corner of the picture, observing it all.

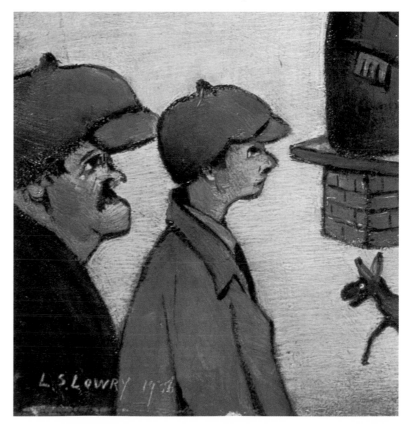

M is for Match

# M is for Match

Lowry was a life-long football fan. He loved watching it and talking about it and, as a boy, playing it. When he was allowed to, that is.

The problem was, his mother didn't want him to play, even though his father coached a local boys' team. She thought it was a rough game and, besides, Laurie would get dirty and that she didn't like one bit. The very thought gave her a headache.

*The Artist's Mother (undated)*

Once, when he was about ten, young Laurie was persuaded by his cousins, Billie and Bertie, to play a game with his schoolmates. They put him in goal and he was the hero of the match because his team won. The other side didn't score a single goal. He threw himself about with such gusto that by the end of the game he was covered in mud. But when he got home, his mother was so upset by the sight of him that she had to call for her smelling salts. He was never allowed to play with Billie and Bertie again.

In 1953, Lowry's painting GOING TO THE MATCH won a Football Association competition. He was very surprised when he heard about it. He did not even know it had been entered. Or so he always said. He pretended to be disappointed.

*"So now I have lost my record of not having ever won anything,"*
he joked.

He would have been even more surprised if he had known that in 1999 this same picture, of people going to watch Bolton Wanderers, sold at auction for the record price for a Lowry of nearly two million pounds. This was eight times as much as all the money Lowry left in his will when he died.

But it was bought by the The Professional Footballers Association… and at that time their Chief Executive was Gordon Taylor, who used to play for Bolton Wanderers at that very same ground.

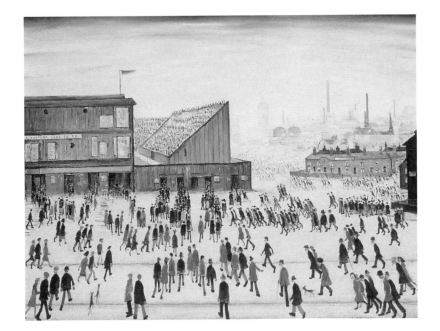

*(opposite) Football Match (1946)*
*Going to the Match (1953)*

N is for (not) Naïve

L Slowry Carlisle 2april 1966

# N is for (not) Naïve

Lowry had been exhibiting for nearly eight years in France, at the prestigious Salon d'Automne, when, in 1939, he was given his first one-man show in London.

In Paris they had praised him for his *"humorous eye of a peculiarly British character"* and his delicate use of paint. In London they dismissed him as a Sunday painter and his work as *"naïve"*.

In certain circles, the epithet stuck. In certain circles, it endures to this day. Lowry, of course, pretended not to mind. *"Are they naïve?"* he said, at his most disingenuous. *"I don't think my pictures are naïve. Are they naïve, do you think? I don't know. I don't intend them to be…"*

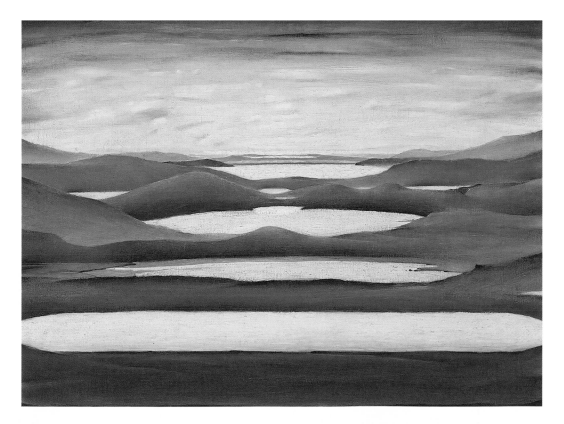

*Lake Landscape (1950)*

Only rarely would his irritation at people's estimate of his art break through:

*"I am tired of people saying I am self-taught. I am sick of it. I went one day to Art School and I said: 'Please, I want to join,' and so I went into the Freehand Drawing Class, and then I took Preparatory Antique, light and shade, and then, after a time, the Antique Class, and when they thought that I was sufficiently advanced in Antique I went into the Life Class.*

*"I did the life drawing for twelve solid years as well as I could and that, I think, is the foundation of painting … And the strange thing is, you can tell whether people have drawn from life from their pictures."*

Outbursts such as this were rare. More often he would resort to his familiar insouciance in the face of yet another description of his meticulously drawn figures as *"matchstick men".*

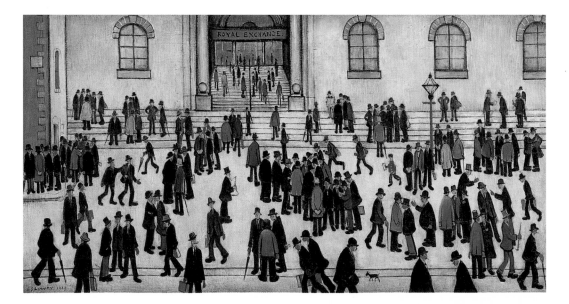

*Royal Exchange (1939)*

*"People call them matchsticks… I don't mind… they may be matchsticks. I just paint figures as I see them."*

Many of Lowry's admirers are inclined to believe that the reason he was so secretive about his day job, as a rent-collector, was to protect himself from the slur of being dubbed an amateur, a Sunday painter. Some of the smarter London critics called him the same thing, only in French: *peintre de dimanche.*

*"I am a Sunday painter,"* he would say with a grin. *"A Sunday painter who paints every day."*

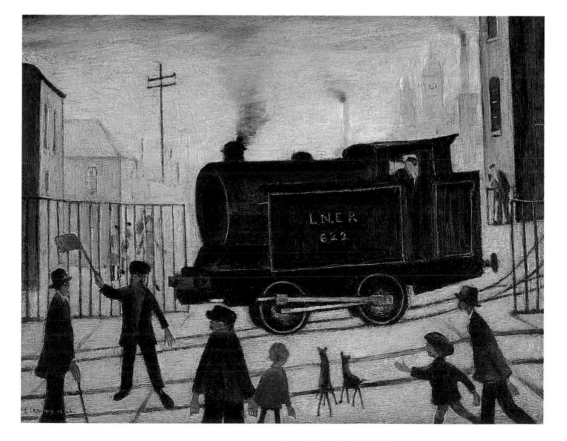

*Level Crossing (1946)*

O is for Odd People

# O is for Odd People

The older Lowry got, the odder his people became. At one point the creatures he drew were so strange that he said to a friend who was looking at these things:

*"Why do you think I do them?"*

He seemed to be truly puzzled.

*"You tell us,"* said the friend, who didn't know what was expected of him.

*"I don't know,"* replied Lowry. *"They just come on the paper."*

Then he paused and, with a huge grin, added:

*"Do you think I am going potty?"*

The reply is not recorded.

*The Group (1970)*

Not, of course, that there was anything new about Lowry
painting the unconventional.

As the Royal Academician, James Fitton, said after Lowry's
death:

*"Many years later, when I had become familiar with the odd figures
that populated his canvas, I realised how very like they are to
himself."*

Even at art school, where the teenage Fitton and Lowry had
first met, the older man was regarded as the odd one out. He
was tall and walked oddly, with his long gangly legs flaying in
all directions, his head stuck out of his collar like a tortoise
from its shell. He had sandy-coloured hair which, no matter
how many times he smoothed it, stuck up like a yard brush.
He looked, said Fitton, *"like a boiled egg with pepper on top"*.

*Funeral Party (1953)*

It was not just in old age that he became somewhat eccentric. He had always been a fair distance from the norm.

If he were talking to someone in the street and he got an itch, he would lean up against a lamp post and rub his back up and down, just like a bear against a tree.

And, if the mood took him, he might jump in a taxi cab in his carpet slippers and ask to be taken to the seaside, two hundred miles away. Sometimes, in smart London hotels such as the Ritz, he would ask for egg and chips just to see the look on the faces of the waiters.

Asked what he did with his old clothes, he replied simply:

*"I wear them."*

And once, at a Royal Academy reception, when a waiter inquired if he would like something to drink, he replied:

*"That's very kind of you, sir, I'll have a tomato soup."*

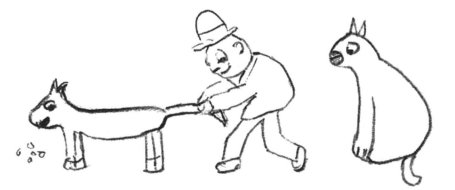

He did not mind what people thought of him. He only cared what people thought of his pictures.

*(top) Offering a Hand (c 1970)*
*Detail from A Game of Marbles (1970)*

is for The Pond

# P is for The Pond

One day Lowry was at home painting a picture. Suddenly there was a loud knock on the door of 117 Station Road, Pendlebury. On the step stood the gas man, whose name was Charlie Ruscoe.

*"I've come about the bill,"* said Charlie. *"You haven't paid it."*

Now, the Lowrys didn't have electricity in their house. Not many people did in those days. They cooked on a coal-burning range and Lowry painted by gas light, which meant it was pretty important to him that they didn't get cut off. But Lowry didn't want to talk about the unpaid bill.

*"Never mind about that,"* he shouted, and grabbed Charlie's arm and dragged him into his workroom. He waved his hand (which was covered with paint because Lowry often painted with his fingers) at a big canvas on his easel. There was a boating lake and lots of small streets and terraced houses, and people with big feet walking about.

*"What's wrong with this picture?"*
he demanded.

Charlie didn't know what to say. He was a gas man, not an art critic.

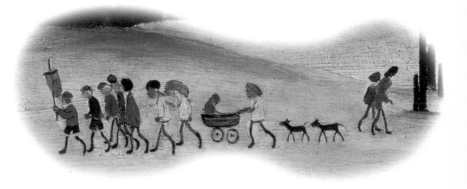

*Detail from The Pond (1950)*

But Lowry liked ordinary people, and children in particular, talking about his paintings, because they didn't try to pretend they knew more than they did or say what they thought he wanted to hear.

*"Go on,"* he kept saying. *"Be honest."*

After a while, Charlie said:

*"Well, er, um, well… if these really were streets round here in Salford, there would be lots of washing hanging out to dry, no matter what kind of a day it was."*

Then he shut his mouth very quickly because he was scared he had made a fool of himself. Lowry was delighted.

*"That's it, that's it,"* he shouted and patted Charlie on the back as if he had done something clever.

Immediately, Lowry started painting clothes all over the place… long johns hanging out of windows and underwear on washing lines and socks dangling from pegs.

That picture is called THE POND. It was one of the first of Lowry's pictures ever to be bought for the great, original Tate Gallery at Millbank in London. And, whenever he is in London, which isn't very often because he's a Manchester Man, Charlie goes to the Tate just to see if his washing is still hanging on the gallery walls.

It was, last time he looked.

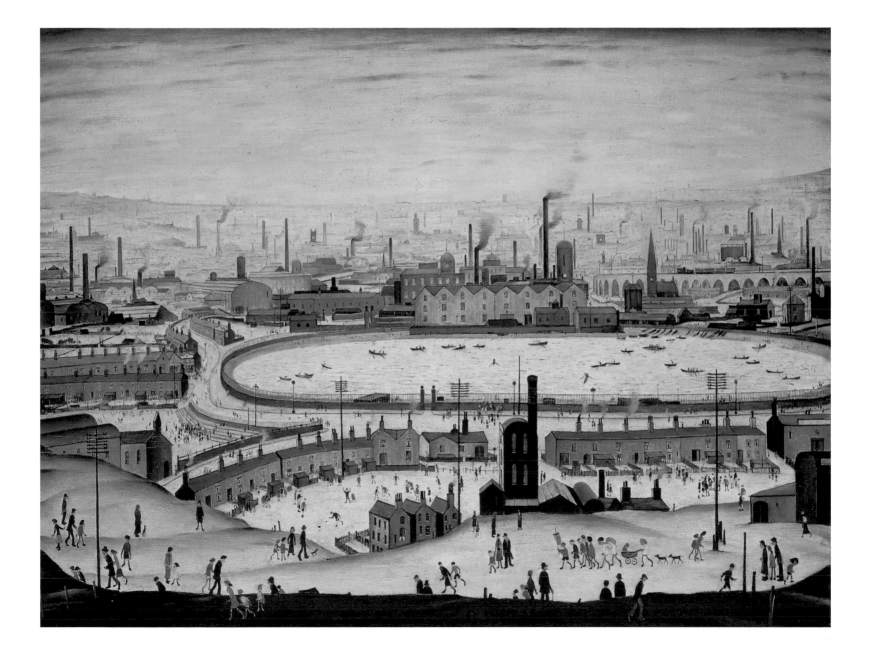

*The Pond (1950)*

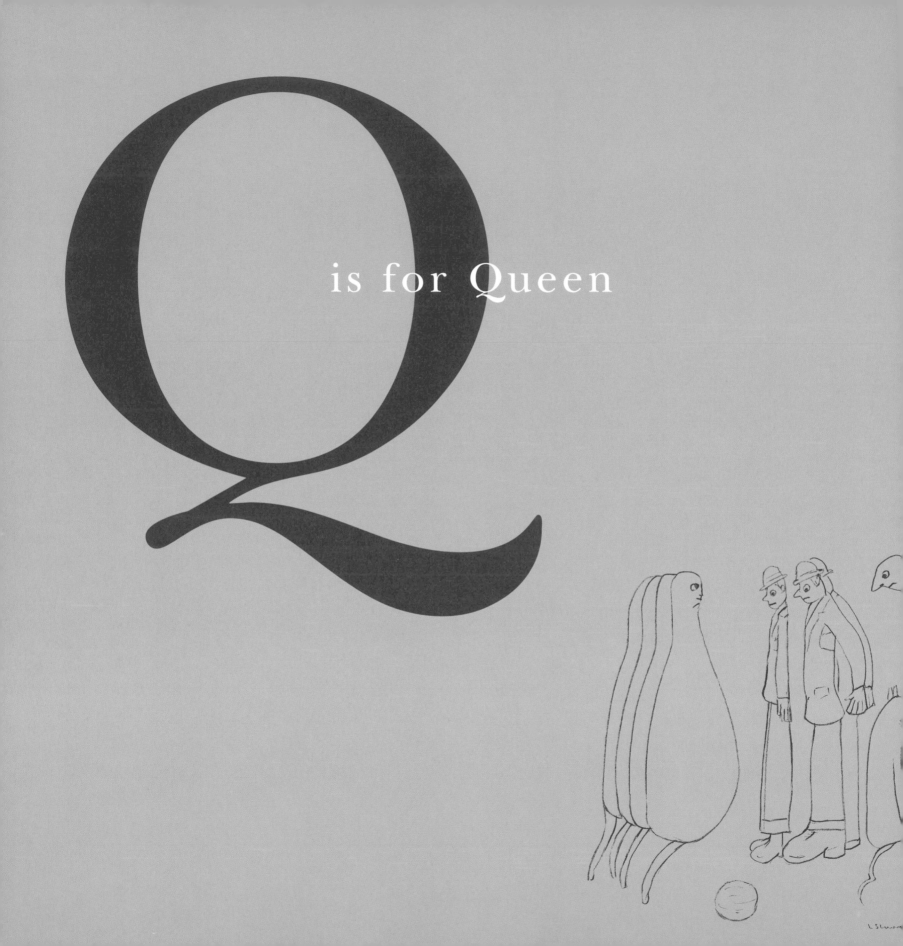

Q is for Queen

# Q is for Queen

Early in 1945, when Lowry was already 57 years old and still working as a rent-collector in Manchester, the prestigious Bond Street gallery of Reid and Lefevre gave him his second one-man London show.

The first had been in 1939 which was unfortunate for Lowry as the art world, along with everyone else, was more concerned with the outbreak of the Second World War than with promoting an unsung painter.

But this second show was to bring the beginnings of recognition. Twenty pictures were sold.

*"This show has been very successful,"* the dealer reported. *"I think it has put you well on the map."*

It was to be crowned by a spectacular sale. Queen Elizabeth, later to become the Queen Mother, had been in the Gallery viewing quite another exhibition when she had spotted the Lowry show and had so liked his painting, A FYLDE FARM, that she had bought it. The ecstatic dealer wrote to Lowry to report that the Queen *"… was greatly interested in your pictures and stayed a long time looking at them. She even said that she hoped to come back on some future date and perhaps buy a more industrial one. Cheers and hurrah."*

*A Fylde Farm (1943)*

When Queen Elizabeth II was crowned in 1953, Lowry was invited to be one of the official artists to paint a picture of that day.

He was rather worried about this. It was not the sort of thing he was used to painting. For one thing, he hardly ever did pictures of London. And for another, he wasn't in the habit of making people look attractive or painting palaces. And he could hardly paint the Queen with big feet.

Anyway, on the great day, he put on his old mac (of course) and stuffed a sketch pad in his pockets with his sandwiches. Later he wrote to tell David Carr all about it:

*"I did all right on the day last week. I fear I didn't get there as early as I ought to have done (six o'clock in the morning was the time they asked folk to be in their places and I would hate to tell you what time I did arrive). The weather was awful in the afternoon, not so terrible in the morning. I was perched in a stand in front of the Palace…a very good view… in fact it couldn't have been better.*

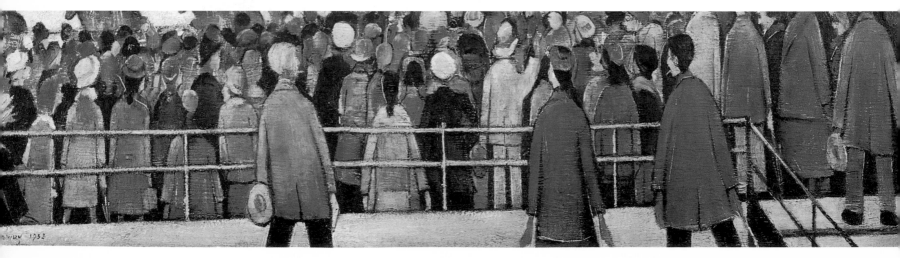

*"What I am going to paint I don't know. Some excellent incidents took place round about which fascinated me but not, I should imagine, what the Ministry of Works want, I am sorry to say… one gentleman, perched up so precariously at the back of one of the stands with a view of nothing as far as I could tell, would have made an excellent picture. He wouldn't come down for anyone, no, not even the police."*

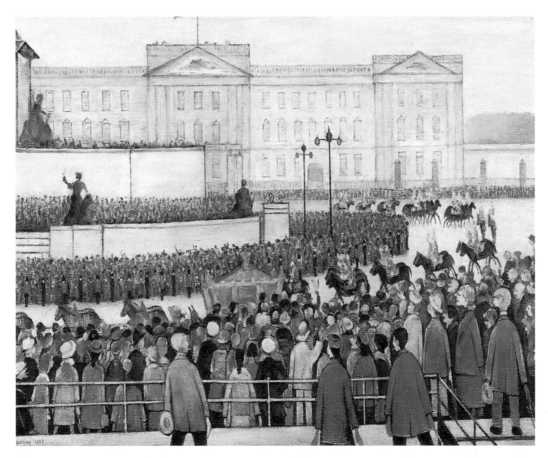

When the Government Office received his Coronation picture, they sent it off to the British Embassy in Moscow where it was put in the second back bedroom and seen by hardly anyone. Lowry, of course, enjoyed this story greatly, and added it to his long fund of tales of rejection to amuse his friends.

*Coronation Procession Passing Queen Victoria Memorial (1953)*

# R  is for Red Eyes

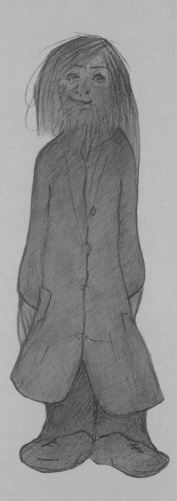

# R is for Red Eyes

Most of Lowry's friends hated the heads he painted. They found them disturbing. MAN WITH RED EYES was a picture he painted when his mother was very ill at home and the full burden of nursing her had fallen upon him. He said that he had got out of bed one morning and looked at himself in the mirror and this is the face he saw.

A young girl, the daughter of a Methodist lay preacher who befriended Lowry after his mother had died, came to visit and saw one of these fearsome-looking men hanging on a wall in the parlour. *"I don't like that,"* she said. *"It frightens me."* *"It frightens me too,"* he replied.

To others he said: *"I was just letting off steam. I was out of my head…"*

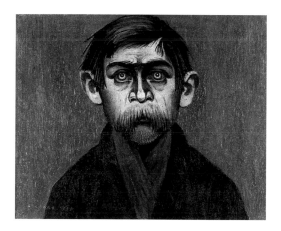

One of the reasons he liked asking his younger friends what they thought of his work, was because he believed they told the truth. They had not learned that most people, when faced with a work of art, pretend to know more than they do for fear of appearing ignorant. Lowry never learned to flannel.

When asked to judge a competition of painting, he would never offer a negative opinion. So far as he was concerned, no picture deserved to be rejected.

*"Anything is valid if you want to do it,"* he would say.

*Head of a Man (1938)*

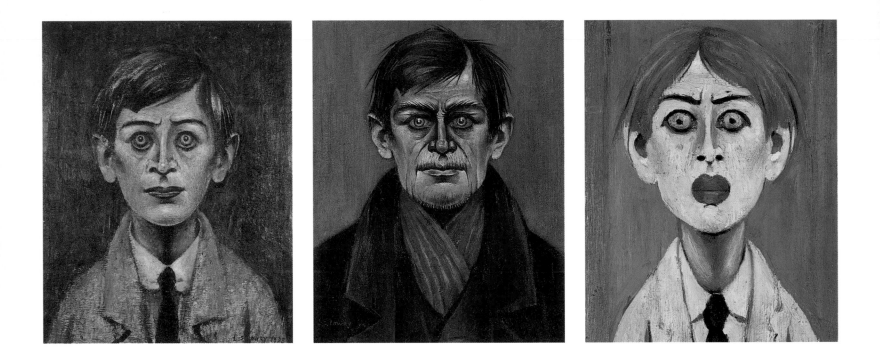

*Boy in a Yellow Jacket (1935), Man With Red Eyes (1938)*
*Head of a Young Man (1955)*

He once dragged a television crew to a public lavatory in Newcastle-upon-Tyne to see the paintings of the attendant, because he thought the man *"had something"*.

He would often buy the work of an artist whom he felt needed encouragement. In 1942, when he shared a Reid and Lefevre show with Joseph Herman, his framers wrote to report several sales, and added *"your neighbour has still done nothing"*. On his next visit he promptly bought a Herman and, in 1955, when they again shared an exhibition, he bought another one and presented it to Salford.

He once sent a painting by landscape artist Sheila Fell to Australia so that she might have wider exposure. After his death, when she was herself a Royal Academician, she said of Lowry:

*"He was the one person I could rely upon to buy and to keep on buying… had it not been for him, I think I would have gone down. Nobody liked my work."*

That last sentence could have been his.

# S is for Sharks

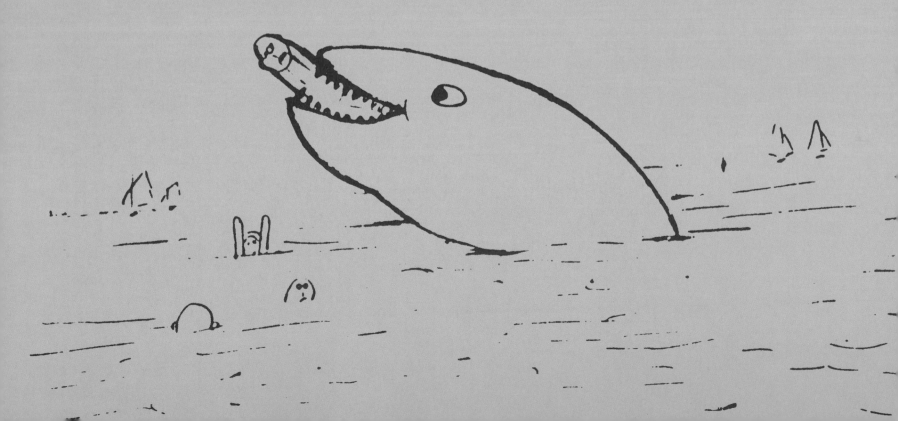

# S is for Sharks

Quite a few of the people who called themselves Lowry's friends thought he was an *"easy touch"* because he often gave paintings away. His excuse for such generosity, not that he would have ever admitted to such a thing, was that he felt enormous gratitude to those who had bought, or liked, or coveted, his pictures in the days when nobody else wanted them. *"Do you really, really like them?"* he would say in tones of awe.

In the same way, in later years, he showed great loyalty to galleries such as The Mid-day Studios, where he had been exhibited at a time when he was being rejected elsewhere. He had a favourite saying: *"It is more shameful to distrust one's friends than to be deceived by them,"* which meant that, on occasion, he would take a chance and trust someone he didn't know well, even if he sometimes made a mistake and gave a gift to a greedy collector.

*Man Drowning in a Sea of Sharks (1970)*

But, as he got older and his pictures began to sell for a lot of money, he would be hurt to discover that someone had fooled him with a lie. Time after time, strangers would come to the door of his dark old house with its overgrown garden and spin a tale about a sick child or a beloved wife who really, really, really wanted a Lowry. But of course they never had enough money. And so Lowry would give them a picture or sell one cheap, and then be disappointed to see that same picture up for auction the very next day.

Once, a dealer in prints persuaded Lowry to put his signature on the bottom of a series of these pictures. Lowry understood that he would be paid £5 for each one that he signed. He knew that these prints, which were not worth much without a signature, sold for a higher price with *"L. S. Lowry"* on the bottom. The dealer would make a lot of money.

When the dealer arrived, he gave Lowry a cheque which worked out at only £3 a signature. Lowry was very good with figures, having spent most of his working life dealing with money. He very quickly worked out the new fee and he didn't like it. But he didn't say anything. He just began signing each print *"L. S. Low"*.

After a while the dealer noticed what was happening. *"What's that?"* he shouted, going red in the face.

*"That,"* said Lowry, trying to hide a grin, *"is a small signature for a small fee."*

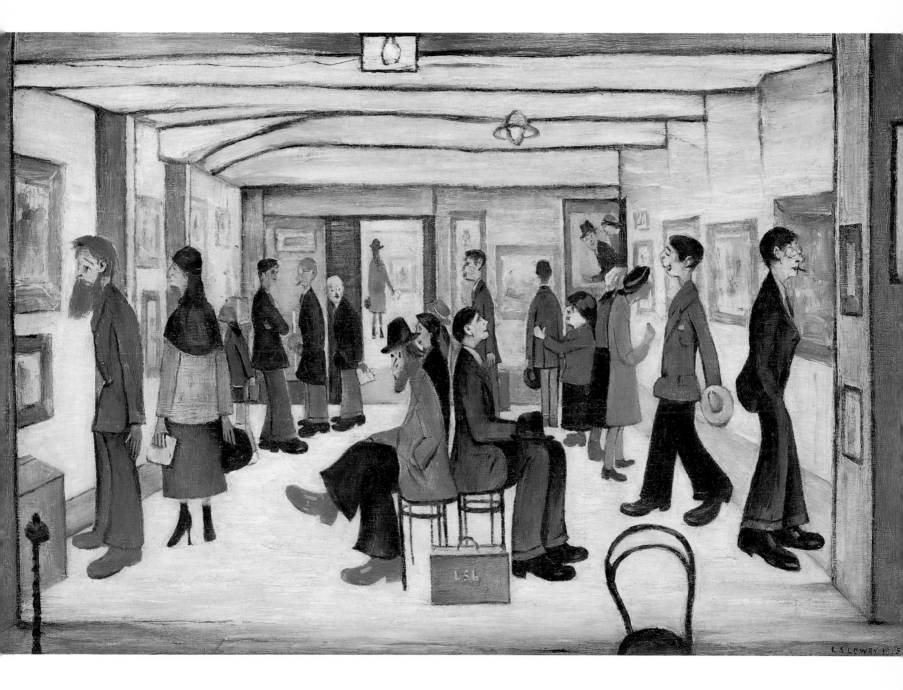

*Private View, Manchester (1955)*

# T is for Trade

# T is for Trade

Whenever Lowry was in London, he would make a point of going into the Royal Academy in the tatty old mac he wore long after it was past its best, simply because it was familiar and, therefore, comfortable.

He would stuff his sandwiches in paper bags in his pockets, along with the inevitable sketch pads, so that his suits and his coats bulged like a hamster's cheeks.

Once inside Burlington House he would wander around, looking at the paintings on the walls, until he came upon a group of venerable old artists. Then he would go up behind them, very softly, and ask in a loud voice with flat Northern vowels:

*"How's trade?"*

This usually made the venerable old men extremely irritable, because they didn't appreciate his humour. They thought of tradesmen as people who sell things, like saucepans and sugar and so on… the sort of people who, when Lowry was a young man, had to go round to the back door or Tradesman's Entrance when they came calling.

*Street Lamp Looks In (1968)*

But, maybe because he was a collector of rents, as was his father before him, and maybe because he worked in the poorer parts of Manchester and Salford, Lowry developed a kind of inverted snobbery that made him deflate pomposity like a small boy pricking a balloon with a pin.

He regarded art as a trade like any other. And dealers as *"grocers who sell paintings"*.

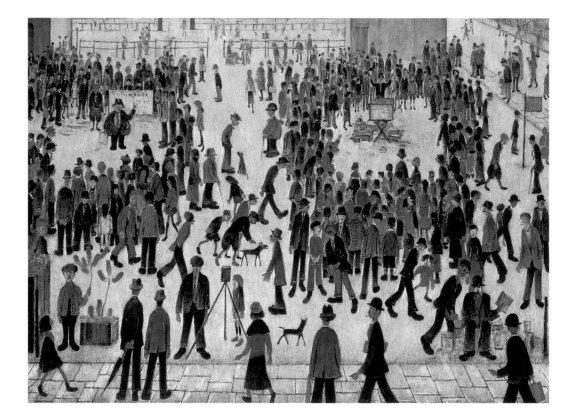

*Open Space (1950)*

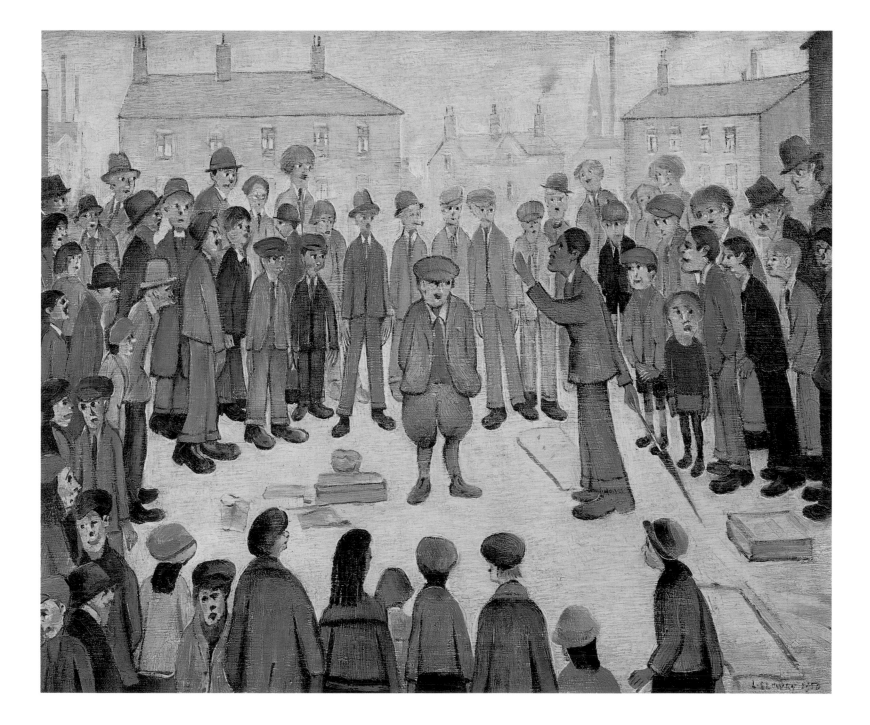

*Street Trader (1950)*

# U

is for Unemployed

# U is for Unemployed

When Lowry was 23 years old, he was made redundant from his job in the offices of an insurance company in Manchester. The family were horrified.

When Laurie had left school at the age of 15, there had never been any question that he would go into business. He was to get a proper job.

*"You can't just do nothing,"* said his mother.
*"Nothing"*, of course, being his painting.

Now it was imperative that he found a new situation and, within a few months, he did: as a rent-collector and cashier.

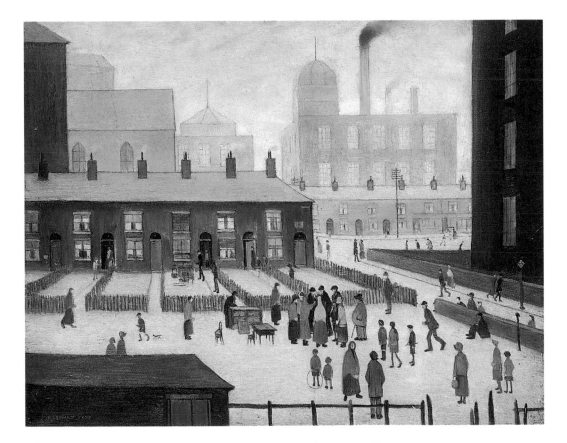

*The Removal (1928)*

Having been brought up in Victoria Park, Manchester, an estate so smart that *"uniformed gardeners dust the soot from the trees"*, Lowry's rude confrontation with poverty and deprivation came as so much of a shock that it was to influence his work for life.

On his daily rounds he came face to face with the reality of unemployment and the perpetual struggle to find the rent each week.

His paintings were never the same again.

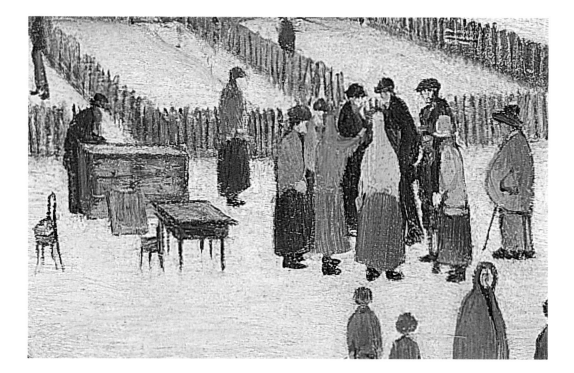

*Detail from The Removal (1928)*

*Unemployed (1937)*

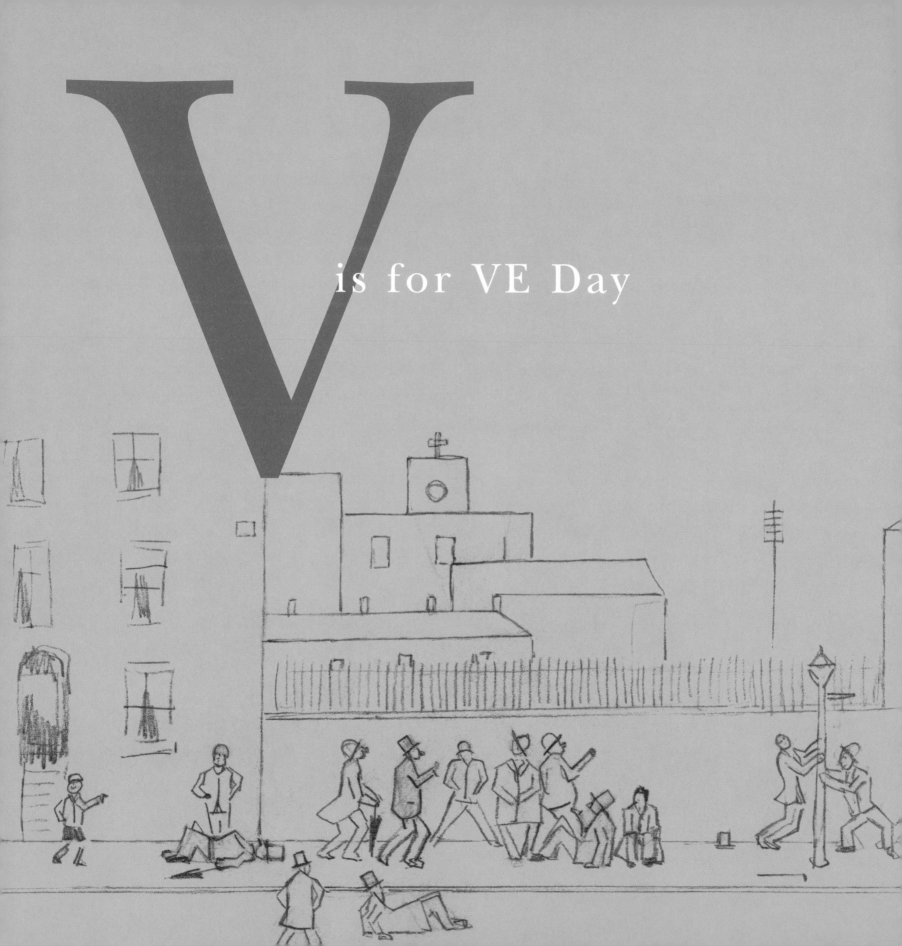

**V** is for VE Day

# V is for VE Day

*"I've a one track mind, sir. Poverty and gloom.*
*Never a joyous picture of mine you'll see. Always gloom.*
*Never do a jolly picture."*

A typical bit of Lowry repartee… and, like most, not strictly true. He did many paintings with a strong comic element… and several jolly ones.

VE Day was probably the most exuberant he ever did. It was done to mark the end of the Second World War.

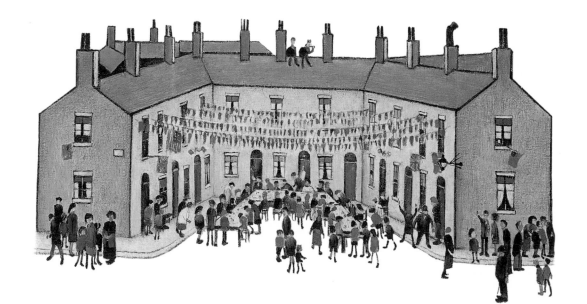

*Detail from VE Day (1945)*

On that day, all the dirty old back streets that grovelled in the shadows of the old mills, were all bright and clean, with flags on the mills and parties for the children and all sorts of great food that the kids hadn't seen for years.

Lowry even put a couple of men in business suits dancing on the roof of a terraced house and, of course, insisted that he really saw such a sight.

*"I only paint what I see."*

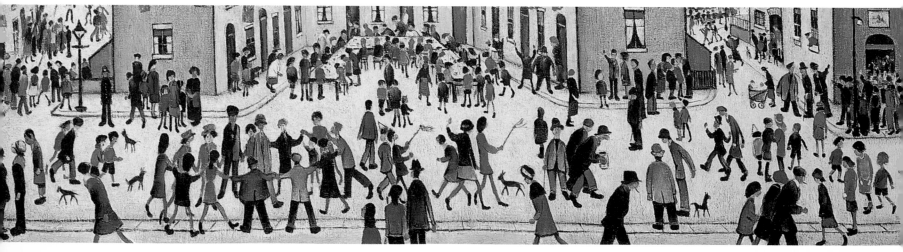

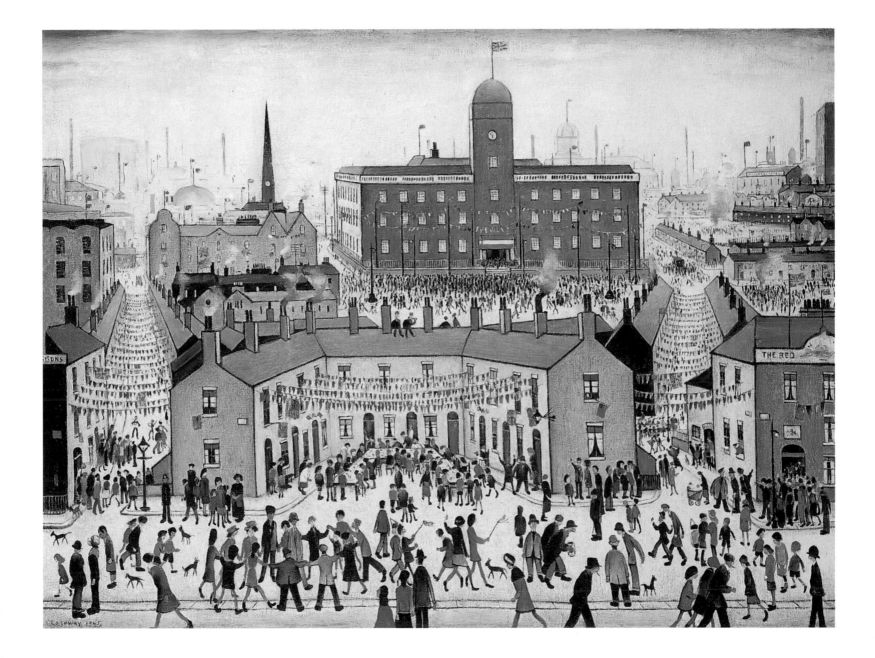

*VE Day (1945)*

W is for White

# W is for White

One day, when Lowry was still at Art School (by then he was already in his 30s), he took some pictures he had *"worked very hard on"* into class. He wanted to show them to Bernard D Taylor, who was not only a teacher, but also the *Manchester Guardian* critic who had written a perceptive review of Lowry's work at an exhibition in Brown Street in 1922. And, as Lowry once remarked, "*My father took the Guardian.*"

"*This will never do,*" said Mr Taylor, hardly looking at them. "*You'll have to do better than that. Can't you paint the figures on a light background?*" "*How do I do that?*" asked Lowry, crossly. "*That's for you to find out,*" came the reply.

Lowry was very put out. He picked up the pictures and

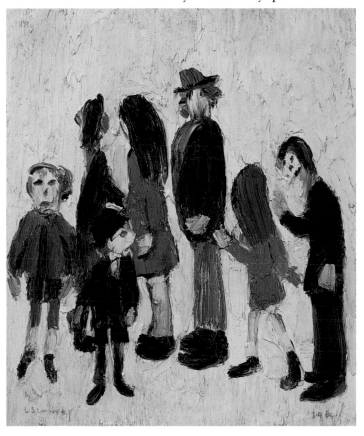

stormed off. "*I didn't like it one bit,*" he said. "*I went home and did two pictures of dark figures on an absolutely white ground. I was very annoyed. Very cross. I said to myself: 'That'll show him. That'll teach the old bird.'*"

*I took them to him and plonked them down in front of him. And do you know what he said? He said: 'That's what I meant. That's right.' I could have killed him.*"

*Group of People (1964)*

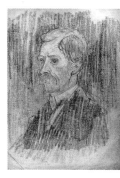

From that time on, Lowry used a great deal of flake white in his pictures and began experimenting to find the best way to use it. He conducted one test that fascinated his father. It was, said Lowry, the only aspect of his art in which his father was interested, a comment which, as with several other of Lowry's throwaway lines, should not be taken too seriously.

*"Once I got a little piece of wood and painted it flake white six times over. Then I let it dry and sealed it up. I left it like that for six or seven years. At the end of that time I did the same thing with another piece of board, opened up the first piece … and compared the two.*

*"The recent one was, of course, dead white. But the first had turned a beautiful creamy grey-white. And then I knew what I wanted. So, you see, the pictures I have painted will not be seen at their best until I'm dead, will they?"*

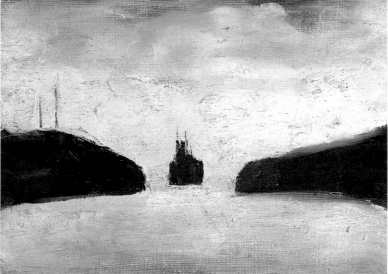

*(top) The Artist's Father (undated)*
*Ship (c 1965)*

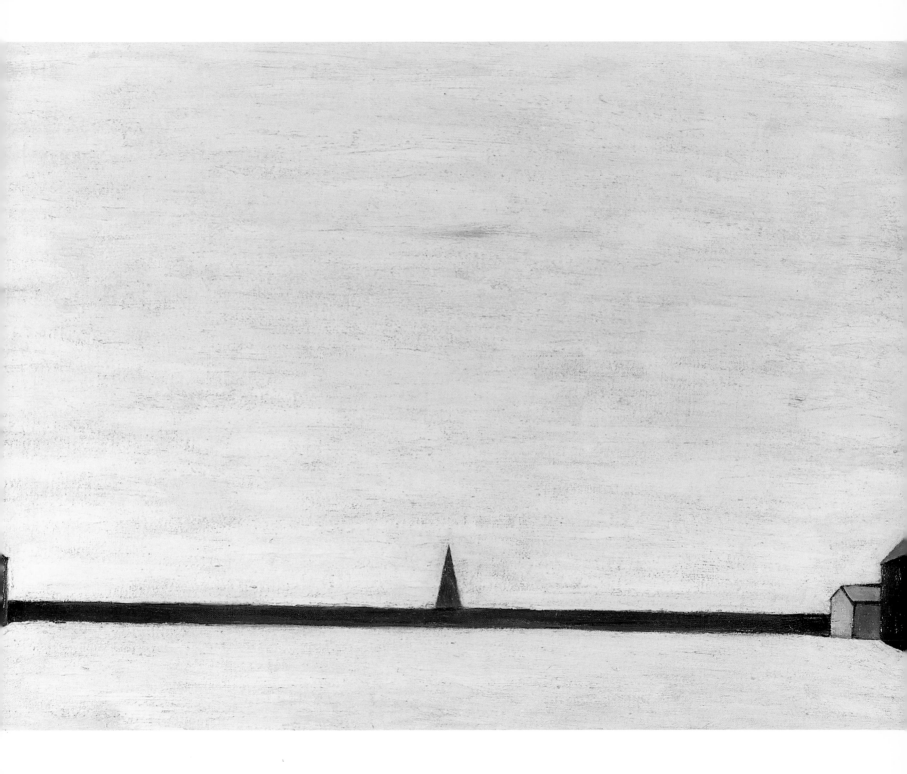

*Church Spire in Maryport (1960)*

X is for X (in the box)

# X is for X (in the box)

Lowry painted several pictures of elections and electioneering. But the one that is the most interesting is called THE RIVAL CANDIDATES.

There are two candidates. One is a man and one is a woman. Which might seem quite normal today, but when Lowry was a young man, women were not even allowed to vote, let alone stand for Parliament.

In ELECTION TIME, the speaker is definitely a man, but there is no mistaking the gender of the candidate in the later picture. She, in fact, bears a remarkable resemblance to Britain's first woman MP, Nancy Astor. Curiously, though,

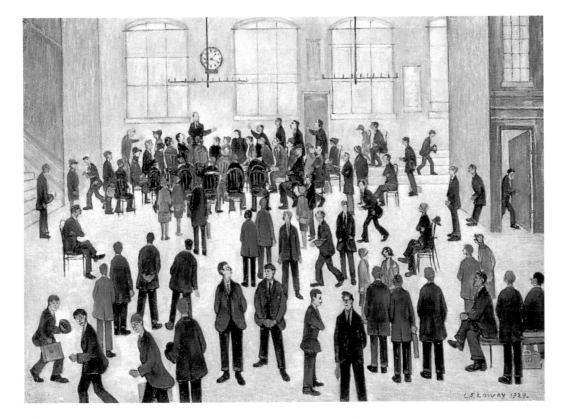

*Election Time (1929)*

RIVAL CANDIDATES is dated 1942, although in wartime there were no elections.

But then, Lowry's dating of his pictures was often arbitrary: when a dealer or friend asked when a certain picture had been painted, he would say: *"What's a good year?"* as if his paintings were vintage wines.

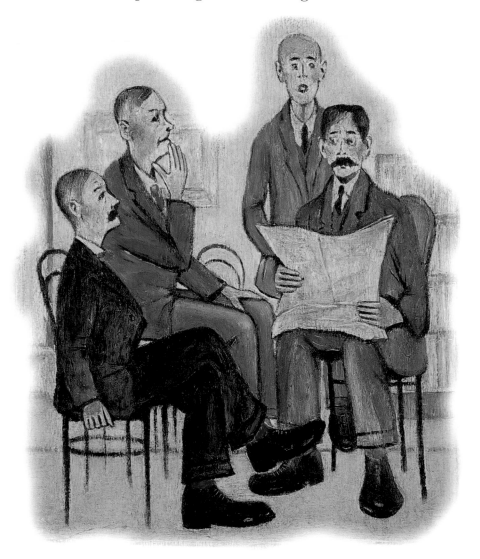

*Election Talk (1945)*

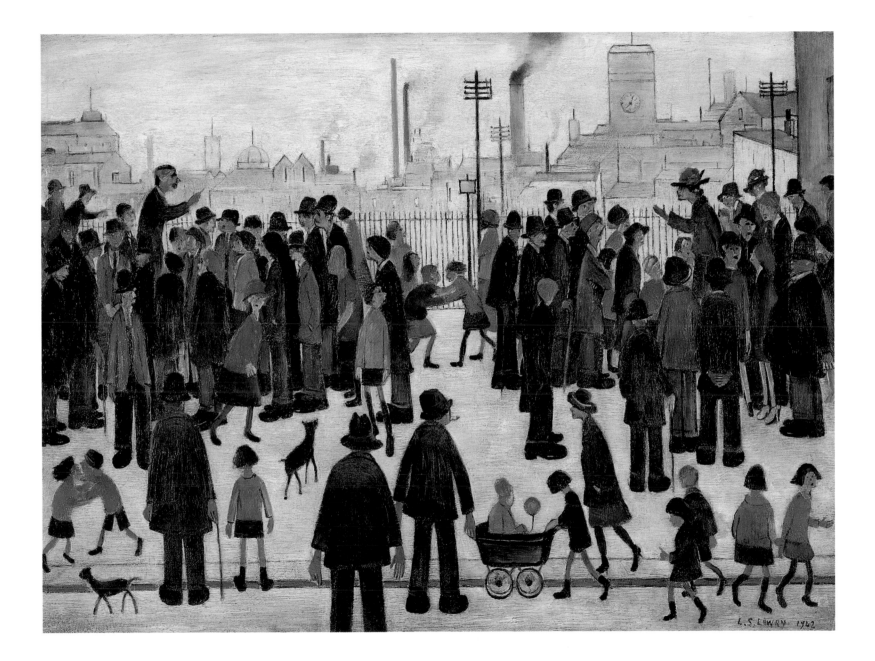

*Rival Candidates (1942)*

# Y is for Yachts

# Y is for Yachts

Elizabeth Lowry never came to appreciate her son's pictures. Quite simply, she detested them. Which was very sad for him, because he loved his mother dearly.

It wouldn't have been so bad for him if she had pretended a bit. But she didn't.

She was always complaining about his paintings and saying how much she disliked them.

*"Why do you have to paint such ugly things, Laurie?"* she would ask in a sad little voice. *"As if it wasn't bad enough to have to live among it, without having you bring it into the house."*

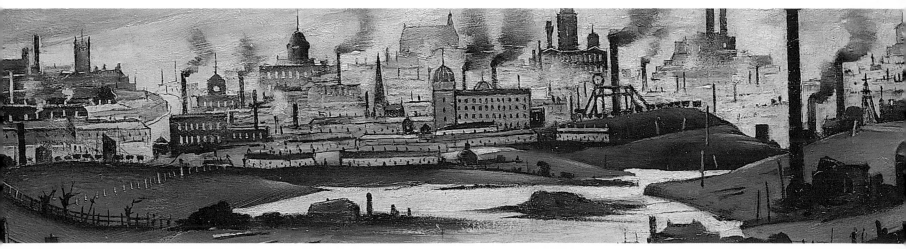

*Detail from The Lake (1937)*

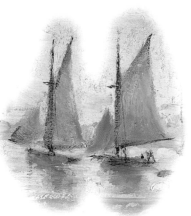

*"What would you like me to paint, Mother?"* he asked,
trying not to show how hurt he was.

*"Why,"* she would say with a brave little smile,
*"you know… little yachts at Lytham."*

And just to please her, that is what he would paint.
He kept her favourite picture, SAILING BOATS, on his wall
at home in Mottram-in-Longdendale, the bleak house into
which he had moved after his parents' death, along with
his Pre-Raphaelites and his portraits of Ann.

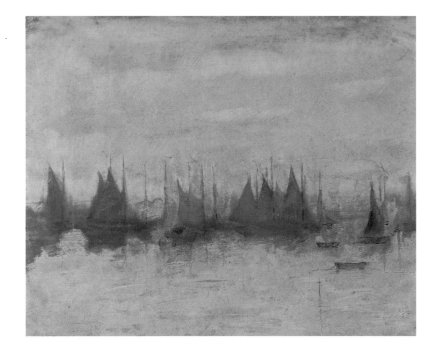

*Fishing Boats at Lytham (1915)*

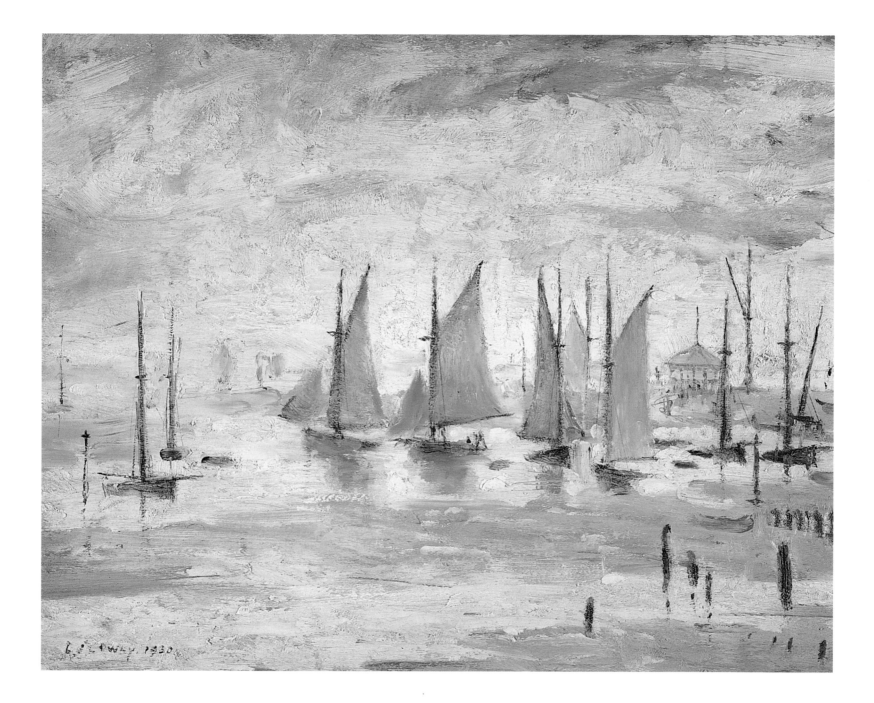

*Sailing Boats (1930)*

Z is for zzzzzzz

# Z is for zzzzzzz

One day Lowry saw a businessman lying asleep flat out on a wall. Lowry knew he was a businessman because he had a bowler hat on his stomach, and in those days businessmen often wore bowler hats. And, besides, he also had a briefcase beside him on the ground.

*"That's me when I retire,"* said Lowry.

And he painted a man lying flat out on a wall, smoking a cigarette, and on the briefcase he wrote his own initials.

In truth, Lowry never did retire. When he was 65, he gave up going into the offices of the Pall Mall Property Company, where he had worked as a rent-collector for 42 years.

*"I'll not be in tomorrow,"* he announced casually one day. And he was not.

But that didn't mean he gave up his real job. He didn't abandon his art. He couldn't. He had started drawing *"little ships and things"* when he was six or seven, and he stopped on the day he died at the age of 88.

*Bloomsbury Square
(1967)*

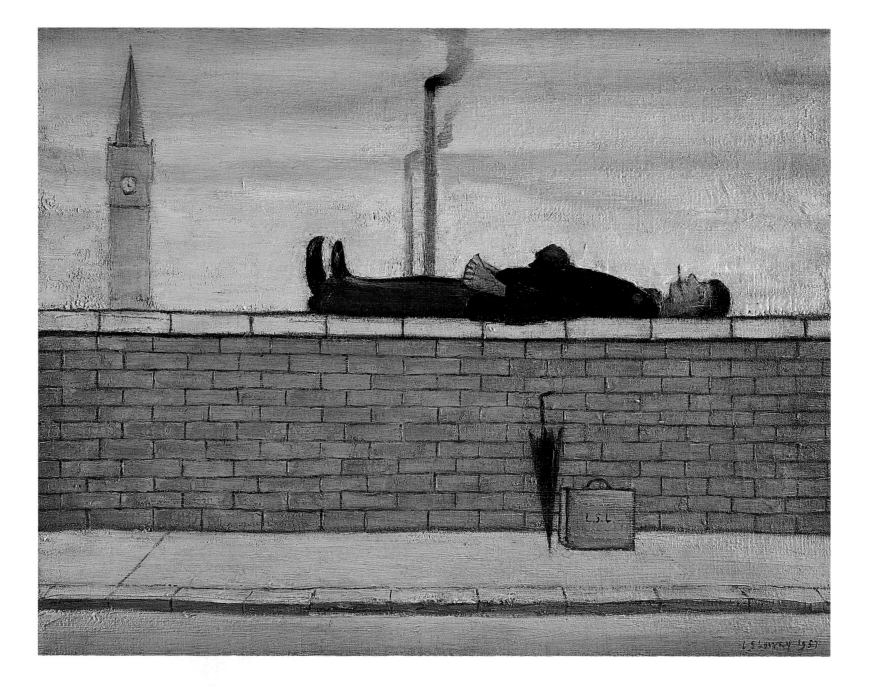

*Man Lying on a Wall (1957)*

Towards the end of his life, Lowry was offered many honours,
all of which he turned down.

*"I have been thanked enough,"* he wrote refusing a knighthood.
*"People have bought my pictures."*

# Acknowledgments

*A book such as this, which aims to be a simple introduction to the art of a not so simple man, could not be made without the help and co-operation of so very many people. I am fortunate in that those I needed have been, without exception, generous in their interest and assistance. My heartfelt thanks, therefore, to:*

*Judy Sandling, Keeper of the Lowry Collection at Salford City Art Gallery for so many years, who was kind enough to read the text and correct my errors, and was tireless in her efforts to help me trace elusive paintings; Mike Leber, Salford's Strategic Development Officer, who has offered nothing but kindness and encouragement over many years even when this book was still a vague idea; all at the Crane Kalman Gallery: Lowry's friend Andras Kalman, his son Andrew and, in particular, Sally Kalman who went to enormous lengths to help me find certain pictures; David Green and Victoria Law at the Richard Green Galleries in Bond Street, London, for kindness and, again, for hunting down paintings for me; the late Pat Cooke, who wrote me detailed letters about L S Lowry until only a week or two before her death; Suzi Lowry for everything, but particularly for letting me use her Lowry picture; as ever, all in Modern British at Christie's, particularly Jonathan Horwich, Rachel Hidderley and Harriet Drummond; Melanie Morgan, Assistant Registrar of the Art Gallery of Western Australia, also their Manager of Information Services, Joyce Carter; all at The Lowry, especially Galleries Director David Alston, Curator Lindsay Brooks, and Charu Vallabhbhai; Graphic Designer Martin Tilley for his imagination and expertise; also Derek Seddon of Salford and Peter Adamson of St Andrews who photographed pictures promptly and without demur, even when they were wanted yesterday.*

*For copyright permission I am indebted to: Martin Bloom whose father, Lowry's friend the late Monty Bloom, owned so many of the pictures featured on these pages; The Tate at Millbank; the Art Gallery of Western Australia; Manchester City Art Gallery; and, of course, the City of Salford. And to those who wish to remain anonymous… you know who you are: thank you.*

*But most of all I owe an enormous debt of gratitude to Carol Ann Lowry, not only for copyright permission, but also for her friendship, her eye and her memories of L S L, all of which she has shared unstintingly. An invaluable gift - without her there would have been no A to Z.*

**The Lowry**
Pier 8 Salford Quays Salford M5 2AZ
Telephone 44 (0) 161 876 2020  Fax 44 (0) 161 876 2021
www.thelowry.com

Publishing and editorial direction by Roger Sears
Art direction by David Pocknell & Martin Tilley
Edited by Michael Leitch
Designed by Martin Tilley

First published 2001  © The Lowry Centre Limited
Text © Shelley Rohde
A CIP catalogue record for this book is available from The British Library
ISBN  1-902970-11-X
Originated in Hong Kong and printed and bound in Spain by Imago